CAMILLE CLAUDEL

Reine-Marie Paris

The National Museum of Women in the Arts
Washington, D.C.
1988

The exhibition *Camille Claudel* and this accompanying publication have been organized by The National Museum of Women in the Arts, Washington, and The Asahi Shimbun.

EXHIBITION DATES

Tokyu Gallery of Art, Shibuya, Tokyo
August 28-September 16, 1987

Tokyu Gallery of Art, Sapporo
October 8-October 20, 1987

Ishibashi Museum of Art, Kurume
October 30-November 29, 1987

Sogo Museum of Art, Yokohama
January 20-February 7, 1988

Daimaru Gallery of Art, Osaka
March 16-March 28, 1988

National Museum of Women in the Arts, Washington
April 25-May 31, 1988

ISBN: 0-940979-04-7

This catalogue was produced by The National Museum of Women in the Arts, Washington, edited by Brett Topping, designed by Susan J. Kitsoulis and translated by Kathleen Cramond.

Note: In this catalogue, unless otherwise indicated, all illustrated works are by Camille Claudel.

Library of Congress Catalog No.: 88-1759

Photographs by Takeo TANAKA
Printed by Otsuka-Kogeisha, Japan

Cover: Detail of *La Joueuse de flûte*, 1900-1905.
Catalogue no. 39

Contents

Foreword

The work and life of Camille Claudel has been known by too few. Although there have been other exhibitions, only a handful of art appreciators outside France have had the opportunity to view her exquisite sculpture first hand.

The core of our exhibition has recently made an impressive tour through Japan organized by The Asahi Shimbun. With their cooperation and the hard work of our co-curators, Reine-Marie Paris and Meredith Martindale, that touring show has been augmented with additional pieces never before seen outside France.

Reine-Marie Paris, the grandneice of Claudel and scholar of her work, has written extensively on the artist's life. Her research for this exhibition brought to light new scholarship on the subject from which we all benefit. Meredith Martindale, widely known for her award-winning film on Claude Monet, has also worked for several years on this topic.

Great joy and sorrow are felt when one examines Claudel's life and work. We are sure that new viewers, as well as those who have already had the opportunity to study her beautiful sculpture, will never forget it.

I am especially grateful to all those who have helped make this show a reality and specifically to Mrs. Wallace F. Holladay, Founder and President of The National Museum of Women in the Arts, and the museum's Board of Trustees who supported this important venture.

Anne-Imelda M. Radice
Director, The National Museum of Women in the Arts

Acknowledgements

We wish to thank the following lenders and others without whom this exhibition would not have been possible: The Claudel Family; private collectors; the Musée Rodin, Paris; Monsieur Jacques Vilain, *Conservateur en chef*, Musée Rodin, Paris; Mademoiselle Nicole Barbier, *Conservateur*, Musée Rodin, Paris; Bibliothèque Nationale, Paris, Madame Florence Callu, *Conservateur en chef*; Bridgestone Museum of Art, Ishibashi Foundation, Tokyo, Mr. Yasuo Kamon, Director, Miss Satoko Kosaka, Assistant Curator; Musée Bertrand, Chateauroux, Mademoiselle Chovin, *Conservateur*; Musée Boucher de Perthes, Abbeville, Madame Agache, *Conservateur*; Musée Eugène Boudin, Honfleur, Madame Anne-Marie Bergeret *Conservateur*; Musée Municipal, Château-Gontier, Monsieur Maurice Sautier, *adjoint au Maire*; Musée de Toulon, Monsieur Le Sénateur-Maire, Monsieur Soubiron, *Conservateur*; Musée Archéologique, Laon, Monsieur le Maire, Madame Caroline Jorrand, *Conservateur*; Musée Bargoin, Clermont-Ferrand, Monsieur Le Sénateur-Maire, Monsieur G. Tisserand, *Conservateur*; Mr. Kenton W. Keith, Cultural Attaché, American Embassy, Paris; Mr. and Mrs. H. William Tanaka; Mr. Hisamitsu Tani, Director for Cultural Affairs, The Asahi Shimbun; Mr. Isami Tateishi, Assistant Director for Cultural Projects, Department No. 1, The Asahi Shimbun; Mr. Tetsuya Kotani, Executive Producer, President, APT Advertising, Tokyo; Mr. Yoshio Murakami, Bureau Chief, American General Bureau, The Asahi Shimbun Washington, D.C.; Mr. Franck Violet, *Directeur,* Universal Favorite Corporation; Monsieur Jean Marais; Maître Arnaud de La Chapelle, *Avocat à la Cour*, Paris; Monsieur Olivier Frapier; The National Museum of Women in the Arts, Mrs. Wallace F. Holladay, President, Dr. Anne-Imelda M. Radice, Director, Brett Topping, Editor, Susan Kitsoulis, Exhibit Designer, Stephanie Stitt, Registrar, Randy Hunt, Randi Greenberg, Katrina Klever, Kathleen Cramond; The Marjorie Merriweather Post Foundation.

Reine-Marie Paris
Meredith Martindale
Co-Curators

Introduction

Since Rodin's emergence on your continent, in the first decade of this century, eighty years have passed, as though unwound from the thread of Clotho, the Fate, until at last, a rival of note has emerged from behind her master's shadow.

This major exhibition sheds new light on an unjust oblivion, and, it is hoped, will restore duly merited admiration for an extraordinary artist.

It is also hoped that the present revelation of Camille Claudel's immense talent will act as a divining rod, on the American public, to help uncover those of her works which may be hidden away in private collections, unnoticed over the years.

The United States was both an introduction and an apogee as concerns the diplomatic career of her beloved brother, Paul Claudel, who first served as vice-consul in New York and Boston, from 1893 to 1895, and just before his final post in Belgium, again as ambassador in Washington during the depression. It is interesting to add here that Camille's most poignant letter concerning her art, (and, in particular, in connection with her very remarkable work called, "The gossips"), was addressed to Paul at the French Consulate in Boston.

So now, over one hundred years after her birth, Camille claudel takes her revenge on fate as she proudly emerges upon the American stage, as if highlighted in the spotlight of her own ever-whirling "The waltz".

Reine-Marie Paris
Co-curator

"Here is an example which is unique...contrary to nature...a woman of genius." Octave Mirbeau, the well-known art critic, was unrefrained in his enthusiasm for "Mlle Claudel," sculptor-*femme* (*Le Journal*, May 12, 1895). However, in the same article, Mirbeau cautioned his readers: "Don't speak too loudly. Some people are upset by Mlle Claudel, and would resent such high praise for her."

There *were* other critics who took favorable notice of this extraordinary lady: Gustave Geoffroy, Louis Vauxcelles and, in particular, Mathias Morhardt. However, with the exception of Morhardt, no one did speak "too loudly." Fire the canons for Rodin; *sotto voce* for "Mlle Claudel." And the public passed by her work, "with eyes like empty sockets."

It was not until 1984, when the Musée Rodin in Paris organized a second exhibition of her sculpture, (the first, in 1951, caused barely a stir), that France "rediscovered" the forgotten sister of Paul Claudel. On the same occasion, with the publication of a major biography, *Camille Claudel*, by Reine-Marie Paris, the artist's grandneice, (Gallimard, 1984), much original material pertaining to her work and to her tragic life, also surfaced.

Success in the past four years has surpassed all expectations. Ignored for three generations, Camille Claudel has suddenly inspired the art, literary, and cinema worlds on an international scale. A lot of this publicity has focused on her love affair with Rodin and subsequent mental breakdown. Thirty miserable years in an asylum prior to her death in 1943 leaves no one indifferent today. Less emphasis in the press and media has been placed on an objective evaluation

of her *oeuvre*. However, the recent exhibition in Switzerland, (*Camille Claudel-Auguste Rodin: Dialogues d'artistes-résonances*, Musée des Beaux-arts, Bern, 1985) has shown that the comparison with Rodin is not exaggerated.

Perseverance against overwhelming odds certainly does not prove the great artist. Nor, for that matter, excellent craftmanship, although we know that even before her encounter with Rodin, Camille possessed a superb technique. If Camille Claudel merits her place among the major sculptors of our modern age, it is because, to paraphrase Mirbeau, her sculpture "uproots our innermost self." What more does one ask of a great work of art?

It is particularly fitting that this exhibition, which presents the latest research on the art of Camille Claudel, is taking place at The National Museum of Women in the Arts. Several pertinent sculptures by Rodin are also included here. To what extent both artists influenced each other's works during their relationship, remains a question, however we can no longer evoke one without at least a reference to the other.

It has been my privilege to collaborate with Reine-Marie Paris, foremost authority on Camille Claudel, since the exhibition proposal almost four years ago. We wish to add our personal thanks to all the many lenders who so generously contributed to this project, and, in particular, to Monsieur Jacques Vilain and Mademoiselle Nicole Barbier, of the Musée Rodin in Paris. We also extend a special note of gratitude to Mrs. William Tanaka and to Mr. Isami Tateishi (Assistant Cultural Director, The Asahi Shimbun), without whose support this exhibition would not have been possible. Above all, our deep appreciation to both Mrs. Wallace F. Holladay and Dr. Anne-Imelda Radice who, on behalf of The National Museum of Women in the Arts, so heartily welcomed this opportunity to introduce Camille Claudel to the American public.

Meredith Martindale
Co-curator

CAMILLE CLAUDEL

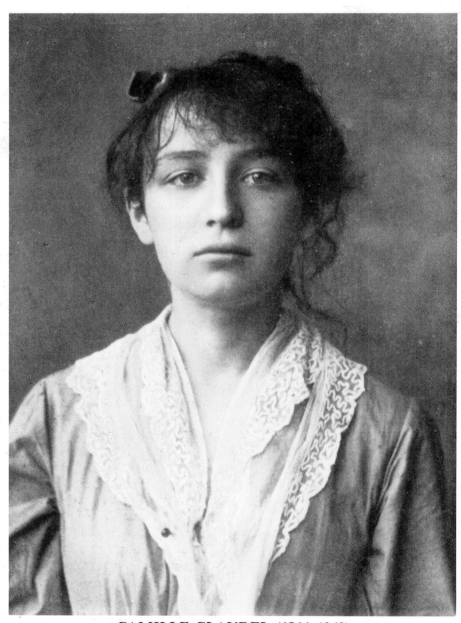

CAMILLE CLAUDEL (1864-1943)

CAMILLE CLAUDEL (1864-1943)

Childhood and Adolescence (1864-1881)

Camille Claudel grew up, untamed by austere farm labor, wind and rainswept forests, in the small village of Villeneuve-sur-Fère near the Champagne region of France. Her father, Louis-Prosper Claudel a civil servant working for the government revenue service, wed Louise Cerveaux. She was the daughter of a doctor and the niece of the village priest. The family lived in the old rectory facing the cemetery, in the shadow of the tower bell which leaned in the wind like a ship's mast.

Camille, the eldest daughter, was given a unisex first name in memory of a brother who lived only a few weeks. A sister born two years later was given her mother's name, Louise, and soon became her mother's favorite. The two of them seemed to form a separate clan within the family – the clan of the Louises – which was never to be penetrated. In compensation, Camille developed strong ties to her brother, Paul, four years her junior, who was to become a famous poet and playwright.

At an early age Claudel molded clay with a wild instinct. She was fascinated by the monsters haunting the wild rocks of Geyn, the nearby forest.

In spite of frequent moves brought about by her father's employment in nearby counties, such as Bar-le-Duc, Nogent-sur-Seine and Wassy-sur-Blaise, the family managed to come back each summer to Villeneuve, with its legends and tales of witchcraft.

While living in Nogent-sur-Seine, Claudel took lessons from Alfred Boucher, a local sculptor. She then went on to create her own first works. All of her early pieces were inspired by conquering heroes, such as Napoleon, Bismarck or David and Goliath, members of her family (*Buste de Paul Claudel à treize ans* [Bust of Paul Claudel at thirteen]) or peasants (*La Vieille Hélène* [Helen in old age]).

In 1881, at the age of seventeen, Claudel convinced her family to move to Paris so that she could continue her training as a sculptor. Her father was left to pursue his career as registrar of mortgages alone in the cities surrounding Paris.

Collaboration with Rodin (1882-1891)

With the encouragement of Alfred Boucher, Claudel attended the Académie Colarossi and rented a studio space on the rue Notre-Dame-des-Champs with some English friends. In 1883 Alfred Boucher was posted to Rome and asked Rodin to supervise his pupils.

Auguste Rodin (1840-1917), who was twenty-four years older than Claudel, was fascinated by her maturity and beauty. In spite of their age difference, the two sculptors developed an unusual and complicated relationship. From pupil , Claudel became a sculptor's assistant in Rodin's workshop, an inspiration, a lover and, ultimately, his rival.

Claudel sculpted the bust of her teacher and lover with rough force. Rodin often sculpted the young woman's portrait, sometimes as a conquering figure like *Saint Georges*, but more frequently as a figure of mystery or melancholy, such as *La Pensée* (The thought), *L'Aurore* (The dawn), *La Convalescente* (The convalescent), *L'Adieu* (The farewell) and *La Jeune fille au bonnet* (Young girl in a bonnet).

Claudel is known to have worked on *La Porte de l'enfer* (The gates of hell) and *Les Bourgeois de Calais* (The burghers of Calais). The resemblance of many other works produced by the two artists make their attribution exceedingly difficult and far from definitive. Compare *Frère et soeur* (Brother and sister) and *Galatée* (Galatea) by Rodin with Claudel's *Jeune fille à la gerbe* (Young girl with a sheaf).

The sirens in Rodin's *La Porte de l'enfer* and *Les Trois muses* (The three muses) are very similar to the three bathers in Claudel's *La Vague* (The wave). His *L'Avarice* (Avarice) evokes her *La Tête de brigand* (Head of a brigand). Rodin's *Le Cri* (The cry) is comparable to *L'Implorante* (The implorer) by Claudel. His *L'Invocation* (The invocation) resembles *La Joueuse de flûte* (The flute player).

The effect of Claudel on Rodin's artistry was to bring out in his works a passion for the flesh and an obsession with couples. The theme of the couple emerged simultaneously within the work of the two artists. Rodin first explored the theme in *L'Eternel printemps* (The eternal spring), *Le Baiser* (The kiss) and *L'Eternelle idole* (The eternal idol). One of Claudel's early couples is *Sakountala* (Sakountala), with its broken neck evoking *La Porte de l'enfer*.

In 1888 Claudel's younger sister, Louise, wed Ferdinand de Massary. Claudel immediately left the family home and settled in a workshop, located on the boulevard d'Italie, rented for her by Rodin. It was a happy time for the two artists, whose work seemed to flourish despite the fact that Camille's financial dependency and Rodin's growing popularity perpetuated her disciple's role.

Independent Creation (1892–1905)

In 1892 Camille decided to break away from Rodin financially by renting her own workshop on the boulevard d'Italie. Her relationship with Rodin lasted a few more years, however, despite the difficulty of Claudel's rivalry with Rose Beuret, Rodin's long-term mistress whom he finally married.

At the Château de l'Islette near Azay-le-Rideau, where the couple hid their happiness, the drama of an abortion drove a further wedge between them. It was during this independent period, before the final breakup which occurred in 1898, that Camille Claudel created her best works of art. They were born out of the agony of a dying passion and rebellion against the actions of a loved, and later hated, companion.

An early group of works reflect the precarious happiness of the couple, or their short-lived reconciliation: the famous *La Valse* (The waltz) and *Sakountala*, which became *L'Abandon* (The abandon-

ment) in bronze and *Vertumne et Pomone* in marble. Others reflect the child she could not bear: *La Petite châtelaine* (The little mistress), also called *La Fillette de l'Islette* (Little girl from Islette), *L'Aurore* (The dawn) and *Petite fille aux colombes* (Little girl with doves).

Later pieces, such as *Clotho* and *Le Dieu envolé* (God flown away), capture the unhappiness of a deserted woman. *L'Implorante* and *L'Age mûr* (Maturity) depict a man overtaken by old age and death. The figure in both works bears a resemblance to Rose Beuret.

A final series demonstrates Claudel's personal style, a style quite different from Rodin's. This group includes *La Joueuse de flûte*, *La Fortune* (The fortune) and *La Vague*, inspired by Hokusai. *La Jeune femme au divan* (Young woman on the sofa), only recently discovered, recalls Manet and Degas. *Les Causeuses* (The gossips) was surprisingly modern for its time. *Le Rêve au coin du feu* (The fireside day-dream) and *La Profonde pensée* (Deep thought), both little known to the public, reflect her depression and loneliness, while *Persée et la Gorgone* (Perseus and the Gorgon), with its emphasis on crawling serpents, signals her emerging madness.

Destructive Seclusion (1906–1913)

In 1899 Camille moved to the ground floor of what was to be her last workshop, at 19, Quai Bourbon on the Ile St. Louis. By this time her relationship with Rodin was over and she had become obsessed with the illusion of a conspiracy by the "Rodin gang" to take her older works, as well as her new creations.

Despite Rodin's triumphs at the Exposition Universelle of 1900, where his Balzac and other inspiring pieces were displayed in his own pavilion, he ceased to create new works at this point. From the time of his breakup with Claudel, Rodin's workshop produced only reproductions of old pieces. The importance of Claudel's influence on Rodin's life and work is demonstrated by the fact that the period of the flowering of his genius coincides with the fourteen years of their stormy relationship (1885–1899). Once Claudel disappeared from his life, Rodin survived in social futility, keeping within the privacy of his workshop. He wed his mistress Rose Beuret on her

deathbed in 1917. His own death followed a few months later, before he was able to give his name to his illegitimate son, Auguste Beuret.

As for Claudel, she lived in seclusion. A display of her art in 1905, organized by the caster of her works, Eugène Blot, was not a success. The lack of popular acclaim, which reoccurred in later years, brought about her increasing poverty. Unable to maintain herself, she turned to her parents, who paid her rent and provided food. Her brother married in 1906 and returned to China. Despite their former closeness, their lives began to draw apart.

At this point Claudel turned her attention once again to her masterpiece *L'Abandon*, renaming it *La Niobide blessée* (Wounded Niobe). Revealingly, the body of the sculpture is stabbed with a mortal arrow.

As her mind became progressively deranged, Claudel locked herself in, bolting all doors with chains and going out only at night. She broke and burned many of her plaster and marble creations. Like the kneeling women of *La Profonde pensée*, she turned her back on life, concentrating on the regrets reflected in all her works.

Internment (1913–1943)

In 1913, following the death of her father, who had always supported her vocation, Claudel's mother and treating physician signed a certificate to have her committed to a mental institution. In accordance with the law of 1838, the doctor of Ville-Evrard hospital confirmed dementia. She was transferred to the Montdevergues Asylum near Avignon with the onset of war in 1914. Numerous monthly statements from attending psychiatrists attest to the fact that Claudel had a delusion of persecution by Rodin and his "gang." Fear of poisoning drove her to refuse any food from the hospital. Her diet consisted of eggs still in their shells and potatoes with their skins on, because they were the only foods she believed to be poison free. Though the law required that the medical corps release a patient who had recovered, that decision was never made in Claudel's case. She accused Rodin rather than her family for her internment, even after his death. She was hospitalized when she was already fifty, so her madness became entangled with senility. She did, however, have occasional lucid intervals, filled with memories of her happy childhood in Villeneuve.

Eugène Blot wrote to Claudel in 1932, "One day when Rodin came to visit, suddenly I saw him standing in front of *L'Implorante*, looking at it, caressing it softly and crying. Yes, crying like a child. He has been dead for fifteen years. Deep down he never loved anybody but you, Camille, I can tell you this today. Everything else, his pitiful love affairs, the ridiculous social life he had, even though he was an ordinary man, was the result of an excessive nature. Oh! I know very well, Camille, that he deserted you. I do not try to justify his behavior, you suffered enough through him. But I do not take back what I wrote. Time will put everything back into its proper perspective."

She died at the age of seventy-nine, during World War II, after a last visit from her brother, Paul. Paul wrote the moving homage "To My Sister Camille" in the literary section of the *Figaro* newspaper at the time of her retrospective at the Musée Rodin in 1951. This and another exhibition which took place shortly before her death were not well received. It was not until the 1984 exhibition at the Musée Rodin that the genius of Camille Claudel began to be more fully appreciated.

Her Work

By the age of twenty Camille Claudel had already mastered her art, inspired by Greek and Italian sculpture. Her first works reflect her classical heritage. *Torse de femme accroupie* (Torso of a woman squatting) and *Torse de femme debout* (Torso of a woman standing) magnificently perpetuated the great traditions of antiquity. *Mon frère* ou *Le Jeune romain* (My brother or The young Roman), *Giganti* and *La Jeune fille à la gerbe* displayed the gracefulness of four great sculptors of the Italian Renaissance, Donatello, Pollaiuolo, della Robbia and Cellini. After Rodin introduced her to the dramatic movements of Michelangelo, she broke away from the Greek sense of harmony with *L'Homme penché* (The man bending over). The long legs so prominent in *La Jeune fille à la gerbe*, a twin of Rodin's *Galatée*, were inspired by *Dawn and Night* in the chapel of the Medicis.

Early in her career an earthy, peasant-like realism

separated her from the Greco-Roman style. *La Vieille Hélène* reflects the lessons from her first teacher at Nogent-sur-Seine, Alfred Boucher. By the age of twenty-four, however, Claudel had developed her own sculpture style, as seen in *Sakountala* of 1888. Her style was different from that taught in art schools and did not follow a trend. This fierce woman from the Champagne district molded her masterpieces with a flair of genius inspired by her homeland.

Camille's works of art were created in a state of precarious mental equilibrium and the dubious balance was on the verge of collapse. *Sakountala* demonstrates a new freedom from control, *La Fortune* stumbles on the road of destiny, *La Joueuse de flûte* sits engrossed in her music, curled on a reef. The man of *L'Age mûr* looks to emptiness for sustenance, while the woman in *La Valse* bends back dramatically, supported only by the arm of her partner. All of Camille Claudel's figures from this period appear immobilized in the moment of grace which preceded her fall and disaster.

In contrast to Rodin's creations, in which all bodily movements aim downward, like a curse, the bodies of Claudel's female figures are curved in a slanting, upward motion. Their legs and feet are bound to the earth, while their souls seem lighter than air, soaring above defeat.

Garments, which are absent from Rodin's works, are sculpted by Claudel, further evidence of her break with academic tradition and the 19th-century style. She does not try to reproduce the material or cloth of the garments; they are not used to decorate the works but to amplify the meaning of the sculpture. In *La Joueuse de flûte* a scarf caresses the mermaid, suggesting a whirlwind of waves and breakers. As she plays, her hands and arms bend to the instrument like the wings of a sea gull and the flute becomes a compass for sailors. The tunic of *Persée et la Gorgone* envelops the adolescent body like a flame. In *L'Age mûr* the clothing sweeps up in the wind like the banner of pirates, a sign of unhappiness. The figures sail as on a funeral barge, under the black flag of decrepitude. Finally, in *La Valse* she sculpts clothes of astonishing modernity, not smoothed by the knife or spatula, but mixed and rubbed down like a Giacometti. The cloth covering the dancers resembles kneaded skin. This heavy chrysalis of sweeping material encloses the couple's glowing flesh in their nuptial flight, which consumes itself in death.

The disturbing theme of a captive head is found in much of Camille's art. In the first version of *La Valse* the couple takes shelter under a cobra-like hood of foaming cloth. In *Psaume* (Psalm) she obscures the face below a large hat from Touraine, which resembles a nun's veil. For *Clotho*, seemingly with premonition, she wraps the figure's head in an immense hat made of yarn, like innumerable years already spun but not yet fully lived. Hair, both disproportionate and enticing, imprisons the heads in *Le Dieu envolé*, *La Vague* and *Les Causeuses*, suggesting a great weight on the brain, in which the bat of terror will soon nest.

Similarly, Rodin only sculpted the covered head of his young mistress beneath a triumphant helmet in *La France*, the hostile rock of *L'Aurore*, a false bride's bonnet in *La Pensée* and with her forehead bound in bandages as if after surgery in *La Convalescente*. The decapitation of the cursed head in Claudel's *Persée et la Gorgone* was her response to this torment.

Claudel internalized Rodin's teaching to a degree as yet unexplored. Her statues are animated by a special force from deep within. They breathe with half open mouths, whispering a mumbled secret into the ear. The secret binds the couple of *L'Abandon* and hovers over *La Valse*. In the corner of the rock formation of *Les Causeuses* the principal figure secretly reveals the ancient mystery of the world in an exchange of breath. Her three sisters sit in a circle in front of her, necks bent forward, heads raised and mouths open like fish to catch the import of her words. *La Joueuse de flûte* represents the mature attempt of an artist striving to invent a sculpture to be seen and heard. One of the last works, *La Fortune*, dances like a drunken gypsy with castanets. She dances without a partner, a princess without a prince. Her weary head no longer rests against a man's cheek but on her own arm as she moves to the rhythm of a fatal flamenco. The most beautiful tribute to the paradoxical union of two arts which she achieved was paid by her friend Claude Debussy, who kept *La Valse* on his desk throughout his life.

All of Camille Claudel's work reflects a sense of threat from the outside world. The passionate face of *La Petite châtelaine* radiates a profound ignorance of mortality, questioning faith and a touch of fear. Confronted with the upward gaze of youth or blind

stare of old age, Camille finds peace by closing herself off from the world. Her need for quietude finds expression in the blindfolded eyes of *La Fortune* and the closed eyes of *Psaume*, *L'Abandon* and *La Joueuse de flûte*.

As a solitary individual, Camille managed to set herself free, first from Rodin's influence and later from an intimacy which negated the need for organized instruction and confined her within the sculpting traditions of the 19th century. Once free, her work rapidly became extremely original. Except for the astonishing Giacometti-like draperies, her *L'Age mûr* was sculpted around a central emptiness, as if she were a future Zadkine.

It is as if her sculpture is touched by the universe on a scale different from that which touches mankind, a special scale seen in the oracle cavern of *Les Causeuses* and the ladies bathing in *La Vague*. She separates herself in this way from European art, in which man is the measure of all things, approaching an Asiatic aesthetic and the Japanese style that she loved so much, in which humanity is measured against the world's immensity.

In the enormous rock walls of *Les Causeuses*, representing onyx or a petrified extrusion of nature, and in the great green onyx wave of *La Vague* ready to jump on the bathers, she created a striking contrast of materials. Through this use of actual and abstracted stone, she achieved a new dimension of sculpture, the dimension of 20th-century art which ties itself to a tradition much older and further removed than magic and sacred art. At the beginning of this century, before her voice was silenced, Camille Claudel had created within her art a new space, a space wherein a strange and hostile world triumphs over humanity.

Note on Camille Claudel Bronzes

Before 1900 Camille Claudel employed the same casters as Rodin: the Thiébaut brothers, Fumière and Gavignot, Gruet, Siot Decauville, Converset and Alexis Rudier. In 1900, the art critic Gustave Geffroy, introduced the caster and dealer, Eugène Blot, to Claudel at her workshop on Quai Bourbon. Blot's foundry was located at 84, rue des Archives, and his gallery was at 5, boulevard de la Madeleine. From the moment they met, all of Claudel's works were cast by Blot.

Blot produced a limited series of her work, which he exhibited in 1905, 1907 and 1908. Blot's correspondence, memoirs and documents relating to his will, as well as records from public auctions, indicate that he felt it best to advertise larger numbers to give the illusion of large orders. Thus, in the catalogue for the 1905 exhibition he claims there were fifty copies of *Les Causeuses*, while in a letter written to Mathias Morhardt, he speaks of having cast only ten. The same catalogue lists fifty copies of *La Fortune*, whereas Blot's *Histoire d'une collection de tableaux modernes* indicates that the edition was limited to twenty.

The largest number that appeared at auction was of *L'Implorante*, no.27. No more than twenty-five copies of *La Valse* were made in bronze *patiné* and only two in golden bronze. Three copies of *La Petite châtelaine* were made, and they do not bear the name of the caster. There were twelve copies of *L'Abandon*, sixteen of *La Fortune* and two of *Giganti*.

The recording of these works by Reine-Marie Paris is now underway and will be included in a catalogue raisonné on Camille Claudel which is being prepared.

Notes on the Works Exhibited

cat. no. 1
Buste d'homme [Bismarck]
Bust of a man [Bismarck]

This head, made of raw clay, was discovered in a municipal building at Wassy-sur-Blaise. According to critics of the day, one of Claudel's early works was an imaginary portrait of Bismarck, which was later lost. Without being absolutely certain of the attribution, this work may well be the missing portrait sculpted by Claudel when she was still in school. The clay comes from a forest near town known as the Red Forest. The hair was sculpted directly by the artist's hands and fingers.

cat. no. 2
Buste de Paul Claudel à treize ans
Bust of Paul Claudel at thirteen

This is the earliest work by Claudel for which the attribution is certain. It was completed at the latest in 1881, before her departure for Paris at the age of seventeen. The bust was sculpted at Wassy-sur-Blaise, during the family's last stay in the country. The work is particularly notable because of its realism. The bulging forehead gives her brother an infantile appearance, distinguishing him from the adolescent of the later work *Le Jeune romain*.

cat. no. 3
La Vieille Hélène
Helen in old age

One of Claudel's earliest works that remains, it was completed when she was seventeen, and was exhibited at the Salon des Artistes Français in 1882. In this portrait of an Alsatian servant of the Claudel family, one can still detect the influence of the artist's first teacher, Alfred Boucher, who had just finished the bust of his old mother. The old woman is sculpted with a wrinkled forehead and pinched lips, furtively scrutinizing the world, like a servant listening behind closed doors. Through this bust of an aged person flows a knowledge of anatomy, which always fascinated Claudel. It is significant that, while still an adolescent herself, she would analyze old age, when time has made and deformed a face. This study required a gift of observation and technique worthy of a much older artist.

cat. no. 4
Buste de femme ou **Buste de Madame de Maigret**
Bust of a woman or Bust of Madame de Maigret

This is a portrait of Madame de Maigret, who commissioned many portraits from Claudel. It is contemporaneous with the marble sculptures of the Maigret family. The bust captures with great charm the soft, compassionate face of an older woman of a distant era.

cat. no. 5
Torse de femme accroupie
Torso of a woman squatting

The enigmatic amputation of this bronze bust prior to its casting results from the impetus for destruction that surfaced at the Quai Bourbon. In his study of 1898, the art critic Mathias Morhardt described the original plaster torso in its integrity. "A young woman curled up on her heels, her back curved and her head resting on her right arm, her arm resting on

her knees, her left arm above her head, and the two hands naturally joined in a simple and harmonious gesture, in front of the right knee." The tragic mutilation of this work gives it the look of an antique ruin and accents its affiliation with Greek art. However, one can also detect the influence of Rodin in the crouching pose, one of his favorite positions. A sensual awareness blended with the great anatomical talent of Claudel is seen here in the tight muscles and curvature of the vertebrae.

cat. no. 6
Mon frère ou Le Jeune romain
My brother or The young Roman

A portrait of her brother, Paul, at age sixteen, before any of his writing had been published. His sister already sees him with the features and posture of a young Roman emperor. His first piece, which appeared five years later, was influenced by Shakespeare's Coriolanus and the Greco-Roman eloquence of young warriors out to conquer the world. Exhibiting an adolescent fragility like a Donatello, the imperiousness of his character is derived from the energy of the features, the honest look and upright neck, and from the tunic thrown over his shoulders like the scarf of young emperors on their triumphal chariots. This work, inspired by Florentine art, is completely independent of Rodin, whose influence it brilliantly precedes.

cat. no. 7
Etude pour l'avarice et la luxure de Rodin
Study for Rodin's Greed and Lust

Kept by the Claudel family at Villeneuve, this study evokes the figures of Greed and Lust in Rodin's La Porte de l'enfer. Here one sees the eyes with a half-closed look and the agonized mouth of the damned. Once again, evidence of the collaboration between the teacher and the pupil casts doubt upon the attribution of the massive work exclusively to Rodin, an expropriation of credit which haunted Claudel's madness after their breakup.

cat. no. 8
Buste de femme aux yeux clos
Bust of a young woman with closed eyes

This woman's bust was offered by the artist's family to the priest of Villeneuve, Abbot Alphonse Godet, during World War I. Its resemblance to Rodin's famous marble Madame de Morla Vicuña from 1884 dates this work to the first years of their relationship. The shape of the chignon is reiterated in the aquiline nose on the figure's angular face. Claudel emphasizes the woman's strangely ungracious physique by depicting her with closed eyes and a breathing mouth.

cat. no. 9
Buste de jeune fille, Louise de Massary
Bust of a young girl, Louise de Massary

This bust was made in 1886, when Claudel was twenty-two years old and her sister twenty. It has energetic and deliberate features, accentuated by a bold hair style. The treatment gives the portrait of her hostile sister the impudent look and mocking air of a society woman. This youthful work is executed in the French tradition of Houdon and Carpeaux, both very much admired by Rodin.

cat. no. 10
Buste de Ferdinand de Massary
Bust of Ferdinand de Massary

Ferdinand de Massary married Louise Claudel, the sculptor's younger sister, in 1888. He died prematurely in 1896, after eight years of marriage, leaving a thirty-year-old widow. From their union was born a son, Jacques de Massary, who became a doctor and married Cécile Moreau-Nélaton. His wife was the daughter of the famous Impressionist art collector who donated to the Louvre, among other works, Manet's famous painting Le Déjeuner sur l'herbe. This bust was made the year Louise married, when Claudel was twenty-four years old. With its oblong face, dreamy eyes and the mustache and goatee of a musketeer, set above a pleated robe and ruffled jabot,

it conveys the elegance and refinement of an aristocrat. It is a work of perfect nobility, free of anxiety or torment, in the great tradition of the Italian Renaissance.

cat. no. 11
Torse de femme debout
Torso of a woman standing

Executed in the Greek tradition, this splendid unclothed torso dates from 1888, one of the first years of her collaboration with Rodin. The rugged modeling and walking posture bring to mind Rodin's constant search for a way of sculpting the body in motion, as distinguished from the equilibrium sought by the academy. The figure's tormented movement is supported by a transverse curve, which creates a dorsal column to control the step.

cat. nos. 12 and 43
Etude de tête d'enfant
Study of the head of a child

This child's head records the fruition of Camille Claudel's complete talent. Its tragic grace, open mouth and big questioning eyes capture the worried astonishment of a child with a fever.

cat. no. 13
Sakountala

cat. no. 16
L'Abandon
Abandonment

cat. no. 69
Vertumne et Pomone
Vertumnus and Pomona

The first large version was displayed at the Salon des Artistes Français in 1888 and signed by Claudel, age twenty-four, with the Hindu name Sakountala. A second, smaller version was cast in bronze by Eugène Blot for his 1905 exhibit. Blot used the title L'Abandon. A third version, in marble this time and yet a different size, was presented at the Salon des Artistes

Français with the title Vertumne et Pomone. The story of Sakountala confirms the significance of this piece.

The great Indian playwright Kalidasa, who lived in the 5th century, wrote the drama of a young Brahman girl. She was seen among her companions by Prince Douchanta when he was hunting a gazelle along the shores of the Ganges. He watches her intently from behind the branches of a mango tree. When he emerges from his hiding place he offers her his pledge of a wedding ring. Sakountala then gives herself to her prince.

When Prince Douchanta returns to his palace to begin the wedding preparations, the heroine, disturbed by her recent encounter, ignores a beggar. He avenges himself by casting a spell on the prince so that he will lose the memory of his love and recover it only in the presence of the wedding ring.

Sakountala soon reaches the court, where her fiancé denies his pledge, the ring having fallen into the lake that morning. Desperate, she flees to the desert, wearing a widow's garb.

One day a fisherman returns the wedding ring, which he has discovered in the stomach of a fish, to the prince. At the sight of the ring Douchanta recovers his memory. Ridden with guilt, he searches without rest for the woman he has repudiated.

Locating her at last, Sakountala enters the room preceded by a young man who bears a resemblance to him. She seems grief stricken. The prince kneels at her feet and confesses his blindness. Once again happy and confident, Sakountala abandons herself to the outstretched arms of her lover.

In this work Camille Claudel gave eternal form to the exchange of supplication and forgiveness that leads to reconciliation. The couple portrayed captures both reunion and reminiscence. The man begs on his knees, heels joined. One arm invites her to waltz, as if with the intention of embracing the hips of the one desired. The other arm takes charge of a body and its destiny. The woman rejects her position. With a limp foot and body tilting toward him, she trusts her lover to supply the support and strength for her to rise. One hand still covers the breast of a future mother, while the other hangs like a ripe bunch of grapes. Her eyelids are closed on the contemplation of happiness.

The two figures are joined, not by hands or lips but by the woman's forgiving temple and the man's eyes,

blinded by the weight of his beloved's head. His mouth whispers into her ear the secret of love which heals all offense.

cat. no. 14
Buste de Charles Lhermitte
Bust of Charles Lhermitte

The young son of Leon Lhermitte, a painter and friend of Rodin and Claudel, Charles Lhermitte became a famous chemist and photographer. One sees here a resemblance to *Le Jeune romain* in the powerful features, direct look, strong nose and vigorous lips. A certain domineering hardness in the first sculpture gives way here to a melancholic softness around the eyes and fullness of young cheeks. The almost feminine head of hair is twisted like a basket handle, forecasting *La Petite châtelaine*. In this bust sculpted in the Florentine tradition, a certain grace calms its feverish torment.

cat. no. 15
Buste d'Auguste Rodin
Bust of Auguste Rodin

While Rodin often sculpted the portrait of his companion, with a melancholic fragility, Claudel only portrayed her lover once in this bust which reveals her intimate knowledge of him. She did not try to embellish his features, but retained his ordinarily rough and fierce appearance. Her magnificent portrayal captures an inordinate vitality. The shape of the face concentrates on his strong forehead. His protruding, arched eyebrows project over the meditative eyes and the prominent nose of the extremely sensuous man, like a snout, according to Paul Claudel. The biblical flow of his beard engulfs the mouth and chin.

A masterful balance subdues the violence of the senses, as well as the character revealed by a mistress still enslaved by her lover. The power of this strangely virile bust is derived from its roughness, devoid of flattery, and the commanding strength of the subject.

All of the ambiguities of Auguste Rodin are concentrated here: the beastly and panic-stricken terror of the Minotaur who swallows young victims and the overriding genius of an ancient prophet or the champion of his dear Michelangelo. Claudel sculpted the bust of Rodin, portraying the majesty of his destiny, in the full bloom of her love, before the pain and hatred destroyed it.

cat. no. 17
Buste de Léon Lhermitte
Bust of Léon Lhermitte

Léon Lhermitte, a painter of the country life admired by Van Gogh and Degas, was the co-disciple of Rodin at the Petite Ecole. Together they founded the Société Nationale des Beaux-Arts. Claudel became a friend of the painter, who was approximately her age, through her relationship with Rodin. This portrait of Lhermitte when he was over fifty years old is animated by a haggard trembling. The eyes sparkle with fever, the eyebrows, mustache and goatee are unkempt, and the wrinkles under the eyelids and nostrils strongly underline his tormented expression. Far from being a complimentary, commissioned portrait, the work strongly expresses the extreme distress of a man who has reached ripe old age. Clearly displaying the affection she felt for the artist, it is one of Claudel's most beautiful character portrayals.

cat. no. 18
Psaume ou La Prière ou Buste de femme au capuchon
Psalm or The prayer or Bust of a lady with a hood

A peasant with heavy features under her large bonnet from Tourangelle. Claudel conveys a sense of her faith through the closed eyes, open mouth and the religious, prayerful mood. She offers herself to a stronger will, her face emaciated by the shadows cast by her hood. This face, sometimes called *L'Inspirée* (The inspired), illustrates Claudel's genius. Without ostentation she transforms a rough sculpture into an enchanting piece through a secret alchemy. Following the creation of *La Petite châtelaine*, all of Claudel's works project brilliantly, without the help of literary artifices or mythological references, an austere classicism of the highest quality.

cat. no. 19
Jeune fille à la gerbe
Young girl with a sheaf

Even though the original in terra cotta is signed by Camille Claudel, the marble reproduction, called *Galatée*, is attributed to Rodin. Opposing the bent forearm are the long legs and prominent knees which meet awkwardly. The work reflects the eloquence of Michelangelo's *Dawn and Night* from the chapel of the Medicis, which Rodin particularly liked. The slim, quick-witted face, with its delicate goldsmith profile, is reminiscent of the Florentine tradition of the quattrocento.

Of the two works by Claudel and Rodin, the only difference is the manner in which the nymph leans, her backdrop a spray of wheat in a quiver of arrows in Claudel's piece, and a primordial rock in Rodin's. For Claudel the woman is a huntress; for Rodin she is a captive.

cat. no. 20
Main
Hand

Rodin often asked Claudel to sculpt the hands and the feet of his works. This hand is the only proof of the anatomical excellence of her work. As elegantly crafted as a piece of Florentine gold, the index finger is raised like a crab's claw.

cat. nos. 21 and 70
La Valse
The waltz

This is the most famous work of art by Camille Claudel, made at the end of her happy times with Rodin. It is also, even more so than *L'Abandon*, her most erotic sculpture. In an early version the dancers were naked. The critics were shocked by the sensuality of the couple, however, and demanded that the sculptor dress her figures. The clothing, imposed by official censure, allowed Camille to unbalance the dancers by adding a fictitious counterweight. The material is represented with an astonishing degree of modernity, not smoothed by the knife or spatula but mixed and rubbed like a Giacometti. Emerging as from a heavy, ribbed chrysalis, the radiant flesh whirls in a nuptial flight, which consumes itself in death. The work was created to be admired from all angles, like a seashell. The twisting sculpture, made in the image of dance, obliges viewers themselves to move around the piece to understand its effects.

cat. nos. 22, 23, 24 and 71
La Petite châtelaine
The little mistress

The daughter of l'Islette, the name of the chateau in the Loire Valley where Claudel hid her pregnancy, appeared to her as the child that destiny would not permit her to know. The model who posed for this work was the daughter of Madame Courcelle, former landlady of the chateau of l'Islette, which accepted paying guests. This admirable portrait is striking for the intensity of the look and the large, burning, inquisitive eyes. The facial features : wide forehead, breathing lips and angled chin , converge toward her eyes which are focused with fear and fervor on the mystery of the world. In one of the versions made in marble, in which the face is more serene, one sees again the heavy head of hair of Claudel's creatures, braided like serpents, recalling *Le Dieu envolé*.

With the bust of this little girl, animated by a passionate spirit, Camille proves once more that she can reach and grasp the secret of great classic art, without resorting to any literal or mythological accessory and without reference to the dramatic movement of Rodin. Moreover, in creating the image of childhood in its timid nudity, Claudel deals with a theme practically ignored by the great sculptors. With the completion of this masterpiece, the artist had molded all of life's ages with her hands.

cat. no. 25
Tête de vieil aveugle chantant
Head of an old blindman singing

This sculpture is similar to others of old age. The two strongest examples are *Clotho* and the angel of death in *L'Age mûr*. Here the sculptor emphasizes the contrast between the eyes, firmly shut, and the mouth,

which is wide open. One can find a relationship between this tragic theme and the victory of Claudel's old rival Rose Beuret, whose allure as a demon appears to have inspired this distorted portrait.

cat. no. 26
L'Age mûr
Maturity

cat. no. 27
L'Implorante
The implorer

L'Age mûr, also named *Le Chemin de la vie*, dramatically exposes the breakup with Rodin. With the objectivity of great art, this autobiographic drama encompasses the tragedy of the humiliated young woman who implores her lover to return and of a man stumbling into his sixties who takes shelter in the arms of old age and death in order to continue on his lonely road. The difference in age between the two lovers appears here like an insurmountable obstacle. Camille sees her youth and the full radiance of her beauty take the shape of a kneeling beggar at the feet of her hero, who turns his head away, captive of the demon of the evening.

The composition of this group is astonishing in its audacity and originality. It is not only the disproportion of the two protagonists created by the kneeling supplicant and retreating man that gives this sculpture its dramatic force, but also its tragic Gothic movement and central emptiness. Here again Claudel, using the void as an element of her sculpture, explores a new course for modern art, a course that Zadkine will pursue. Claudel's great themes are summed up here. The young woman immortalized in her tormented grace is related to the figures of *Les Causeuses*, *La Vague* and *La Joueuse de flûte*. The man, on the other hand, is treated with a ruthless realism. His wrinkles and the veins in his face and hands change him into an old tree trying to take roots in the abyss. The old woman is reminiscent of one of Claudel's nightmares – her *Clotho*, the ancient blind one singing with the dead look of howling cat's eyes or the spectral figure of the man with folded arms. The blowing cloth carries the figures on the wind of shipwrecks, like a banner of pirates and umbrella of

misfortune. The group sails as on a funeral barge, the sacrificed beggar in full view, the man oscillating at the mast, under the black banner of decrepitude.

cat. no. 28
Le Dieu envolé
God flown away

A major work of art, sometimes mistaken for *L'Implorante*, the piece precedes the tragedy of Claudel's breakup with Rodin, given tragic expression in *L'Age mûr*. Here, the kneeling young women holds herself straight. She is not begging but, rather, astonished as she experiences the disappearance and betrayal of hope. Her suffering is expressed like a lost moan, without the ferocious, avenging rage she will later display toward the man who denied her. The heavily braided head of hair is rolled up, twisted like serpents surrounding her head. One sees here the living roots of *Clotho* and, later, *Persée et la Gorgone*.

cat. no. 29
L'Ecume
The foam

This marble nude on an onyx pedestal dates from the last period of Claudel's short career. The conjunction of these two materials make the piece contemporaneous with *Les Causeuses* and *La Vague*. The gracious model, smooth in appearance, recalls the quietude of *L'Aurore* and *Le rêve au coin du feu*. Claudel reestablishes a more classical tradition, bare of any interior drama. Even with her concern for worldly elegance, she manages to convey a new and precious charm through the opposition of the rough onyx, like bare rock, and the seductive curves of the graceful bather.

cat. no. 30
Femme à sa toilette
Woman at her dressing table

A rough rendition of a familiar scene, it is perturbing because of the unusual portrayal of the raised curtain.

cat. no. 31
La Vague
The wave

This work, created in 1898, is free of any Western influence. It assimilates an aesthetic of different constraints without losing its singularity, reflecting the passion of late 19th century European artists for Japanese art. The optical illusion of a heavy swell of gigantic proportions, threatening three nymphs like a wild animal's claw, is undoubtedly taken from a Hokusai engraving. The genius of Claudel is seen in the unusual use of two distinct materials – onyx and bronze – in the execution of this piece. The water nymphs are sculpted with the grace of innocent merry-go-round children. The sculptor employed all her dexterity to make their dancing movement light, recalling the three muses that she sculpted for Rodin's homage to Victor Hugo. The mermaids are related through the proportions of their bodies and heavy manes of hair to *Les Causeuses* and the young women of *Le Dieu envolé* and *L'Implorante*.

Claudel does not try to imitate the edges of a wave nor its fringe of foam in the onyx, which she polished with a mutton bone. She animates the stone without really relating it to the natural form she is depicting and succeeds in expressing the strange monstrosity of the wave's hostile force. It is captured at a moment of danger, when it stands erect like a cobra, just before it breaks into foam. Here one finds once again a moment of suspended grace, caught an instant before its collapse. The same feeling of suspension imbues *La Valse* and other of Claudel's figures who know only a fugitive happiness under the menace of a disaster so sudden that the victims do not have time to feel the terror.

cat. no. 32
Chien rongeant son os
Dog gnawing a bone

In this sculpture of a starving dog with prominent ribs, sterile dugs and cut tail, sagging toward the food, one sees again Claudel's gift for astute observation. It also illustrates her mocking ferocity, referred to by her brother, Paul.

cat. no. 33
La Profonde pensée ou **Femme agenouillée devant une cheminée**
Deep thought or Woman kneeling in front of a fireplace

One of the artist's last works, the figure of a woman turns her back on life, transfixed by the roaring fire in which plasters and terra cotta sculptures are consumed. It is a terrifying vision of one voluntarily interned at Quai Bourbon, a solitary performer at a ritual of destruction, holding within her two upraised arms the boundary of her despair. Kneeling, her head weighed down with grief, the artist bows as if for all eternity before the ashes of her terminated life. In this ultimate gesture of resignation, Claudel maintains a theatricality which connects her with her playwright brother, Paul. The *causeuse* (gossip) or *baigneuse* (bather) now smashes her skull against the onyx. This work of art, which embodies the last stage of Claudel's distress, has only recently been recovered.

cat. nos. 34 and 35
Persée et la Gorgone
Perseus and the Gorgon

A winged monster with a serpentine head of hair, the Gorgon had the power to change whoever looked at her into stone. The young Perseus succeeds in decapitating her through a ruse – by taking aim at her in a mirror-like shield, without having to confront the deadly look. With one hand Perseus holds up the bloody trophy of the slaughtered head, continuing to look into the shield without turning his head. The shield is broken today, as if the monster retained her evil power. All the intensity of the work is focused on the petrified look of the adolescent who has sustained the impact of the horror. The heavy, bruised face of the Gorgon bears a resemblance to Claudel at the age of forty, her features deformed by hardship and haunted by insanity. This similarity was noted by her brother, Paul. More profoundly, the snake-like head unconsciously resembles her rival sister, Louise de Massary, who, in an unedited letter before her internment Claudel imagined making a secret pact with Rodin and sealing it with a kiss on the mouth.

The magnificent marble sculpture has a flow of

movement like a flame burning at the stake. Although the body and wings of the Gorgon lie at the victor's feet, above the cross of outstretched arms, the monster's head facing the missing shield continues to rule today.

cat. no. 36
L'Homme aux bras croisés
Man with crossed arms

A study in terra cotta, this is without a doubt another of the damned from *La Porte de l'enfer*. The arms are those of a captive; the cave-like eyes drown in the night. Left at Villeneuve, it resembles the sculpture *Giganti* (1885), which was mistakenly attributed to Rodin.

cat. no. 37
L'Aurore
The dawn

This is a subdued version of *La Petite châtelaine*. This child baptized *L'Aurore*, like a pale light emerging from a thick, dark head of hair, dates from the artist's last period. The soft modeling distinguishes it from Rodin's tormented style. In its childish grace trembles a secret hurt. The faces of children became symbols of respite during Claudel's martyrdom.

cat. no. 38
La Fortune
The fortune

Among Claudel's last works of art, *La Fortune* dances like a drunken gypsy, with castanets and blindfolded eyes. She stumbles on the road of destiny, waltzing without a partner, a princess without a prince, her weary head no longer leaning on a man's cheek but on her own arm. The heavy clothing, as unrealistic as that in *La Valse*, has the same characteristics of mixed elements, amplifying the daring movement of the tragic diagonal created by the arched body, the backwardly tilting head and the raised arm.

cat. no. 39
La Joueuse de flûte
The flute player

According to Eugène Blot, *La Joueuse de flûte* was Claudel's favorite piece. The woman's body is one of the most beautiful created by the sculptor's hands. As always with Claudel's later work, there is great movement and action. The knees are joined, the feet clutch the reef. The manner in which she is seated emphasizes the tension of the legs and curve of the back. Her neck is stretched and her head tilting toward the flute directs the musician like a conductor's baton. The flute (which Claudel had envisioned sculpting in shining metal with the reef in green onyx) commands the center of the sculpture, like a navigator's compass. The curve of the arms and the scarf turn like a whirlpool. The clothing, a whirlwind of waves and undertow, gives wings to a sea bird in harmony with the rescuing song. The hands and arms resemble the motionless flight of sea gulls, soaring over the waters and reefs, carried along by the mermaid's melody.

cat. no. 40
Les Causeuses
The gossips

Of all Camille Claudel's creations, this is the most audacious and strange. It is a work without reference or ancestry. It emerges from a prehistoric art and presages the most modern sculpture. According to a private statement made by the artist to art critic Mathias Morhardt, it does not really matter that the origin comes from the observation of four gossips sitting in a narrow compartment of a railroad car, except as a measure of the genial transfiguration of a scene of daily life into a timeless rite of initiation. In a gray, hidden corner of a rock, the central figure sits, like Pythia, the priestess of Delphi, facing her three sisters who are seated in a closed circle. She whispers the ancient secret of the world in an exchange of breath as, with naked torsos, raised heads and mouths open like fish, they lean close to catch her words. Liberated from her past and liberated of all tradition, Claudel here creates her own mythology. She invents a new space – the fourth dimension of height. The

walls of the cavern of revelations, toward which the figures face, turning their backs to the viewer, are of another dimension than that of man. In this cavern, molded in bronze with its granite streaks and quarry-stone joints, is reflected the great wall of mystery which surrounds the universe. The leaning bodies of the three listeners, responding to the same force of concentration and curiosity, form a gothic structure, to which the mouth of the narrator is the key. With her hands cautiously raised against her breath, the central figure, toward whom everyone converges, increases the seriousness of her secret. Perhaps never in any of her other works of art is Camille Claudel's attraction to ancient Western and Oriental art displayed with such force. Naked and seated on benches, their faces diffused with intensely active expressions, these figures recreate a primitive art that the 20th century will perfect.

cat. no. 41
Buste de Paul Claudel à trente-sept ans
Bust of Paul Claudel at thirty-seven

This portrait of Claudel's brother was made in 1905, upon his return from China. She had not cast a bronze of him since Le Jeune romain, in which he appeared as a young conqueror. In this portrait he is a mature man, whom time has made heavier and more solid. All youthful grace has disappeared, leaving the more mundane dignity that comes with age.

cat. no. 42
Buste de Paul Claudel à quarante-deux ans
Bust of Paul Claudel at forty-two

This is Claudel's last portrait of Paul, executed in 1910. The playwright still has a look of imperious domination, along with an air of severity and strength of character.

cat. no. 44
Etude de tête d'enfant
Study of the head of a child

This study of a head has been improperly described as a child's head. In fact, it resembles Jean D'Aire, one of the burghers of Calais sculpted by Rodin. Its vigor and energy, as well as the similarity of the features, testify to the role Claudel played in the creation of one of Rodin's best-known masterpieces.

cat. no. 45
Etude de tête de jeune fille au chignon
Study of the head of a young girl with a chignon

This study of a head was renamed "Tête de négresse" by mistake. It radiates an evil charm, with its open mouth articulating silent words and its bulging eyes covered by blind eyelids.

cat. no. 46
Tête de vieille femme
Head of an old woman

The old lady's head is exposed in all her pitiful decline. All trace of femininity has disappeared. The protrusion of the nose and the forehead accent the disgrace of advanced age. The connection of this work with Clotho and the old lady of L'Age mûr is striking.

cat. no. 48
L'Homme penché
The man bending over

This captive, enchained by his own arms, is without a doubt one of Claudel's works most directly inspired by Rodin's style. The seemingly broken neck and head, leaning toward the floor, recall Adam and the shadows of the inferno. Unlike Claudel's future works, one finds here again her attraction to Rodin's figures that are pulled into hell, as if subjected to a tragic gravity. Despite the strong likeness between this piece and those of her teacher, Claudel invents the movement of the figure's arms grabbing one foot. Rodin later borrowed this gesture, which appears to immobilize the narrowness of human action, in his work Le Désespoir (Despair). Examining this striking piece, one sees that Claudel understood immediately the secrets of Rodin's creations, even in their most virile tragedy, with an understanding that enabled her

to achieve equal mastery. These secrets could have helped her begin a career of even greater proportions.

cat. no. 51
Petite fille aux colombes
Little girl with doves

This painting mourns the forbidden young child who haunts the years of separation with Rodin. In this scene Claudel imagines her child dead in a peaceful sleep, with her head on a big silk pillow, wearing a crown of leaves and drawing toward her the birds of eternity that approach after their long flight over the sea. Her face, which her mother will never know, is hidden by shadows. This is a lament for a deceased child, tapping with its intimacy the realm of the subconscious.

cat. no. 53
Jeune femme au divan
Young woman on the sofa

This painting reveals a world unknown until then in Claudel's art. One discovers a secret talent for painting. The mix of the black and pink colors, the elegance of the draped dress and cape, the feather hat and the nonchalant pose of the model raise this canvas to the level of two great portrait painters who worked in a similar style, Manet and Degas. One cannot help but dream of the fabulous career this worldly painter could have had, which she refused out of faithfulness to an austere vocation, even as she held in her hand the brushes that could guarantee her financial freedom.

cat. no. 68
Portrait d'une amie anglaise
Portrait of an English friend

This oil painting is signed by the artist and dated 1900. Recently found in England, it is believed to be the sculptor's self-portrait at the age of thirty-six. A photograph taken in England by her friend Jessie Lipscomb's family bears a perfect resemblance to the portrait, down to the black dress with buttoned collar, jewels and necklace with a golden cross, a surprising addition for one previously so irreverent. Claudel, wearing her brother Paul's consular hat, already emphasizes her prominent lower lip. Her hair, which is combed in a vigorous backward sweep, is reminiscent of *Persée et la Gorgone*.

cat. no. 69
Vertumne et Pomone
Vertumnus and Pomona

The third variation, in marble, turns the Hindu tale into a Latin poem. Scythe-flourishing Pomona, the goddess of orchards, safe from the fauns and their god, Priapus, within her enclosed garden prunes and trims barks while grafting new twigs. Prowling about comes the shame harvester, Vertumnus, the fruit-picker, vainly offering his basket full of wheat. Disguised as an old woman, he steals into the secret garden and, eulogizing the vine thriving on the male elm, awes the insensible maid into respect for such vengeful gods as hate, the proud-hearted. On seeing the handsome youth, the nymph yields, wounded by the same shafts. And her vine-like bowing arm engrafts itself into the dorsal tuft of the goat-legged satyr.

Comparing *Sakountala* (1888), to *Vertumne et Pomone* (1905), commissioned by the Countess of Maigret, one can span the whole course of Camille Claudel's talent: a wild and choppy burst of youth, as shown by the figure's abruptly slumping neck, similar to Rodin's *Shades,* is followed by a smooth and graceful mildness; the fierce shriek has quieted into the secret inward harmony of a perfectly controlled art.

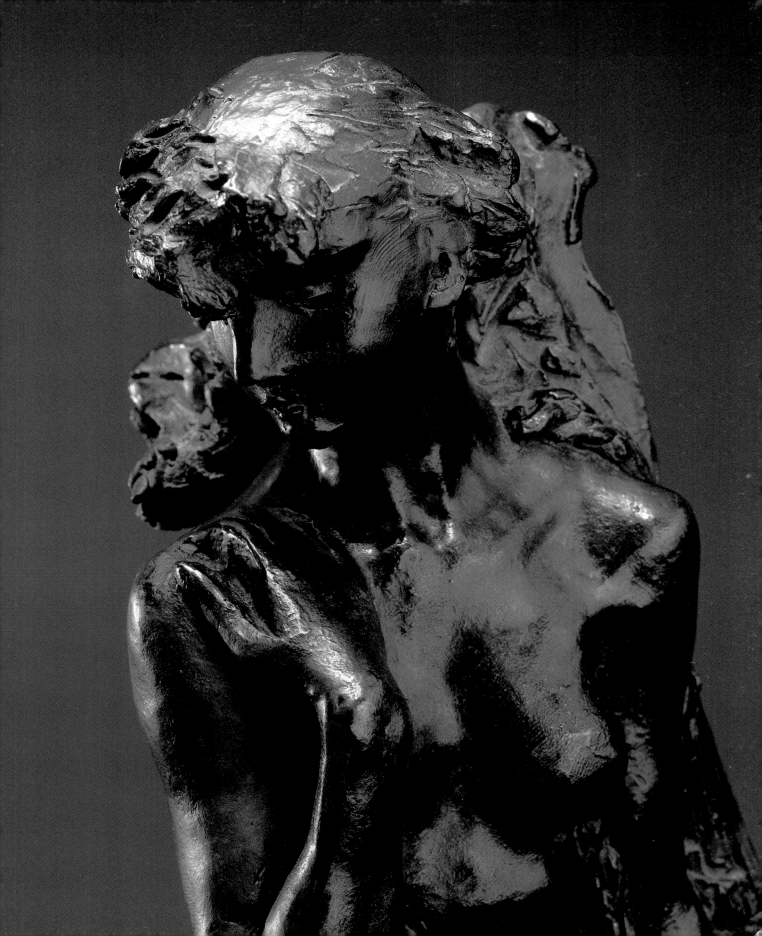

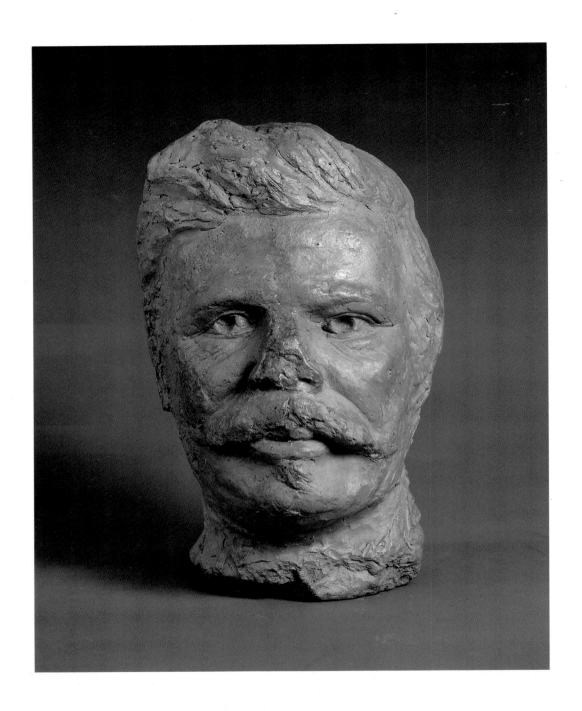

1.
Buste d'homme ⌈***Bismarck***⌉
Bust of a man ⌈Bismarck⌉
1879–1880
(Attributed to Camille Claudel)
Clay, 11 7/8×7 7/8×11 7/8 in.
On loan from Ville de Wassy

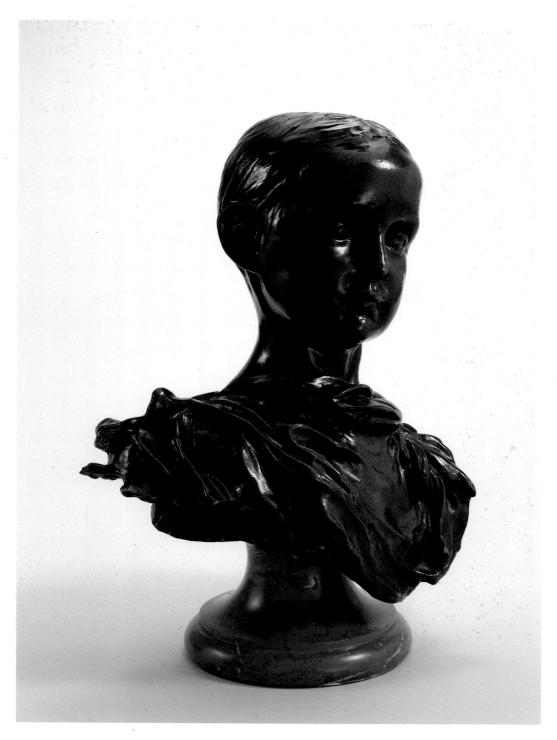

2.
Buste de Paul Claudel à treize ans
Bust of Paul Claudel at thirteen
1881
Bronze on block of red marble,
15 3/4×14 1/8 in., 2×8 5/8 in.
Musée Bertrand de Châteauroux

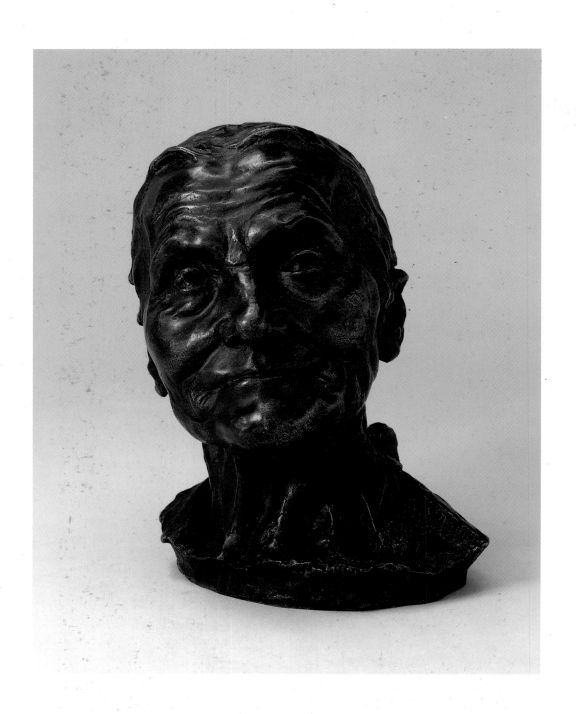

3.
La Vieille Hélène
Helen in old age
1905
Bronze, 11×7 1/8×8 1/4 in.
Private collection

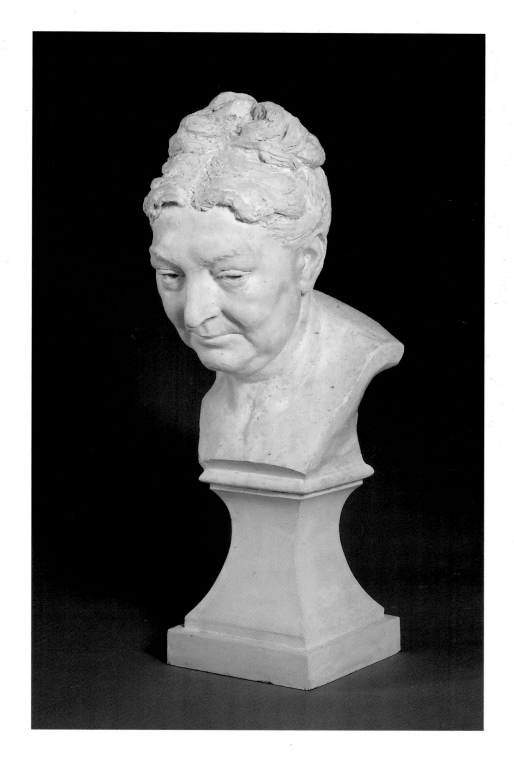

4.
Buste de femme ou ***Buste de Madame de Maigret***
Bust of a woman or Bust of Madame de Maigret
ca. 1900
Plaster, 15 3/4×8 5/8×4 3/4 in.
Private collection

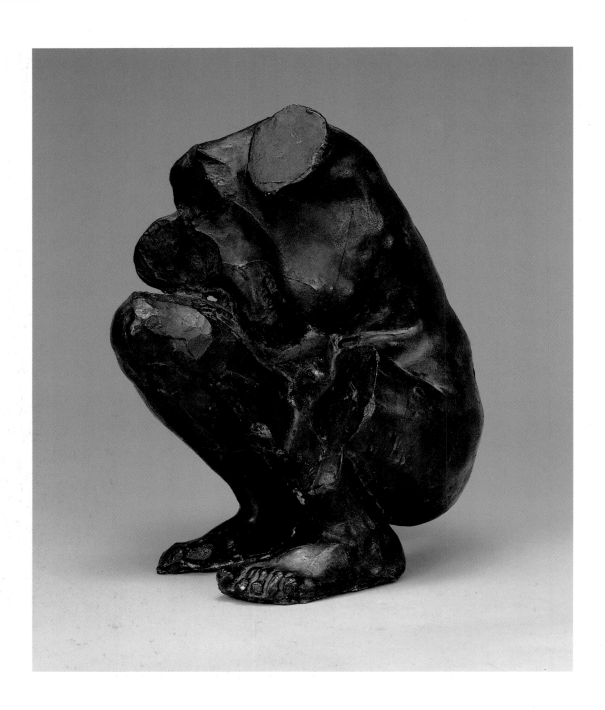

5.
Torse de femme accroupie
Torso of a woman squatting
1884-1885
Bronze, 13 3/4×8 1/4×7 1/2 in.
Private collection

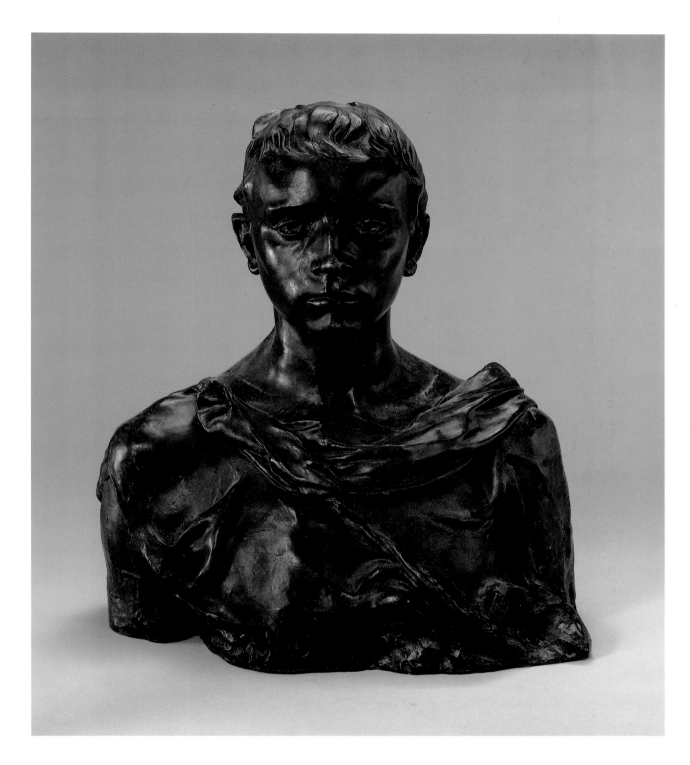

6.
Mon frère ou *Le Jeune romain*
My brother or The young Roman
1884
Bronze, 17 3/8×17×9 1/2 in.
Musée de Toulon

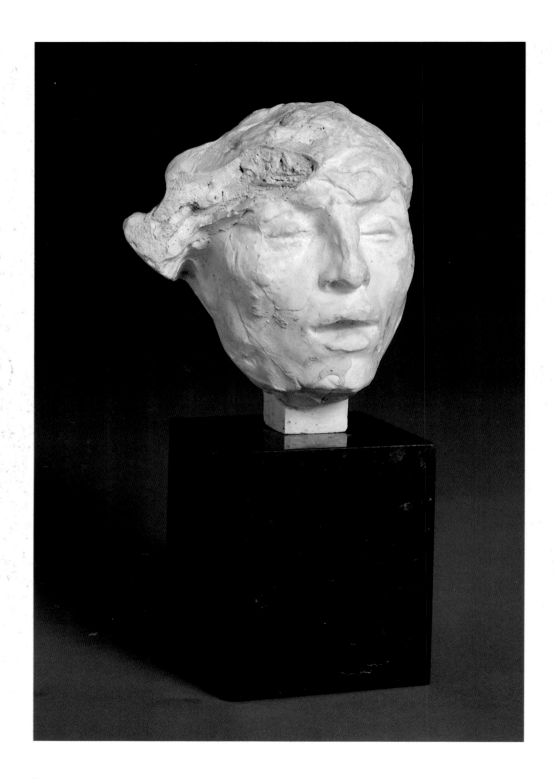

7.
Etude pour l'avarice et la luxure de Rodin
Study for Rodin's *Greed and Lust*
1885
Plaster, height: 7 7/8 in.
Private collection

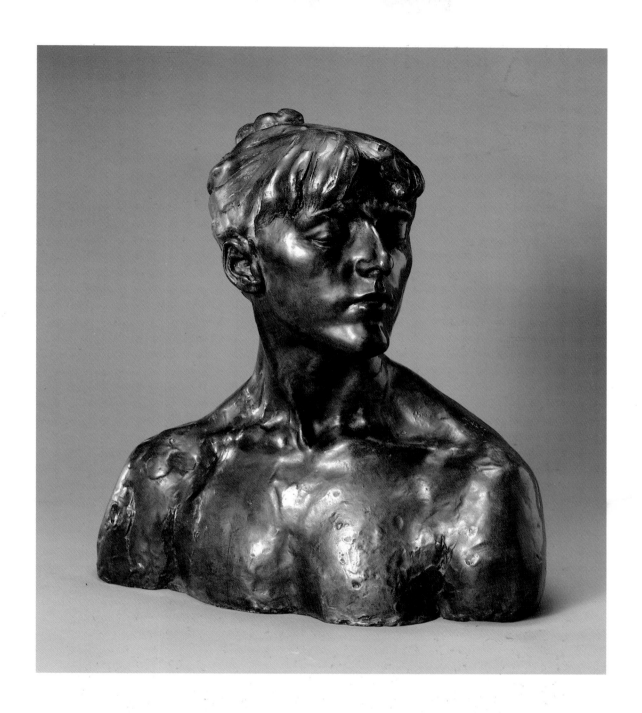

8.
Buste de jeune femme aux yeux clos
Bust of a young woman with closed eyes
1987
Bronze, 14 5/8×13 3/4×7 5/8 in.
Private collection

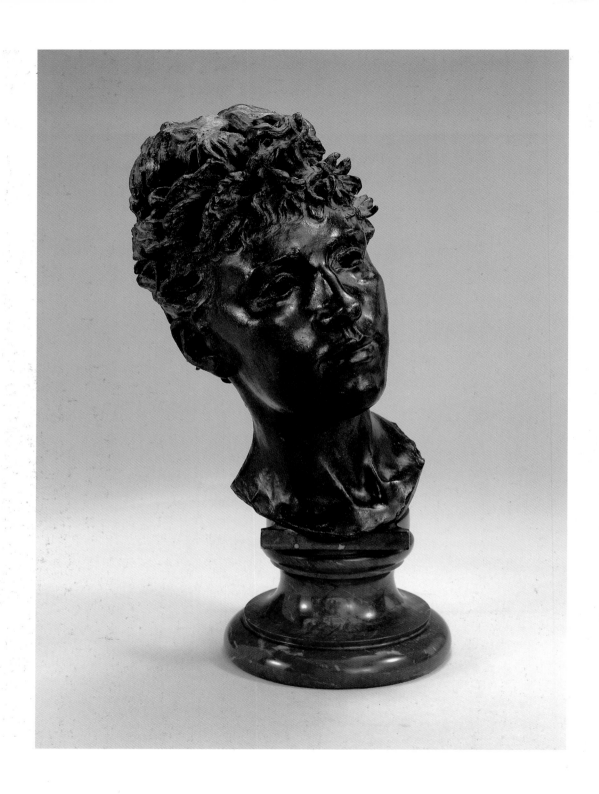

9.
Buste de jeune fille, Louise de Massary
Bust of young girl, Louise de Massary
1886
Bronze, 19 3/8×7 1/8 in.

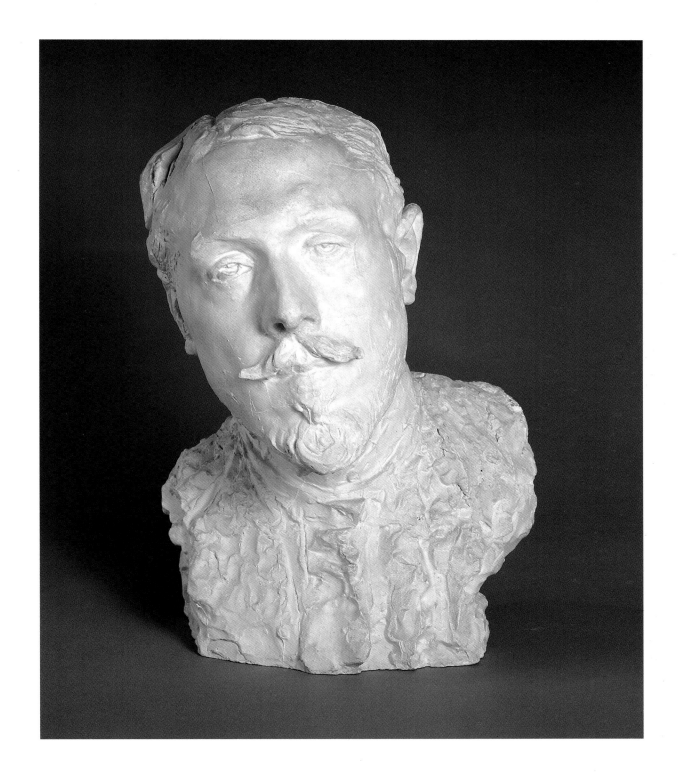

10.
Buste de Ferdinand de Massary
Bust of Ferdinand de Massary
1888
Plaster, 17×11×11 7/8 in.
Private collection

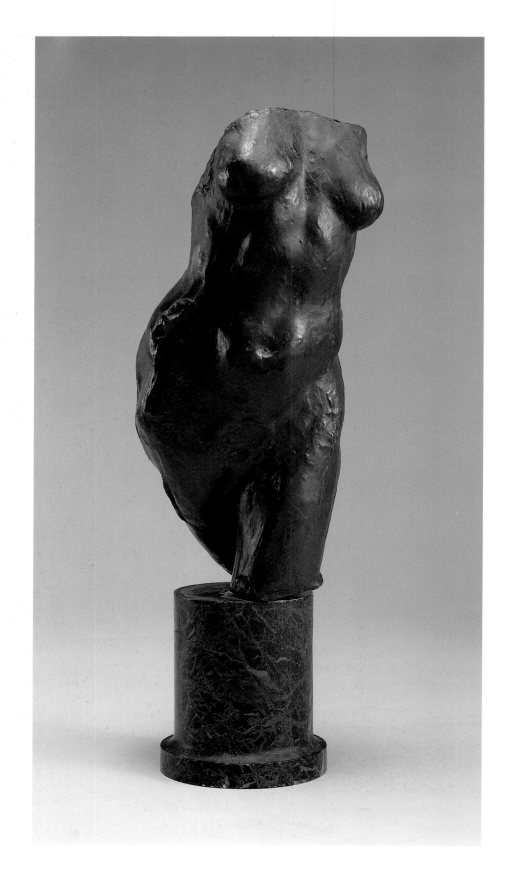

11.
Torse de femme debout
Torso of a woman standing
1888
Bronze, 19 3/8×6 3/8×13 3/4 in.
Private collection

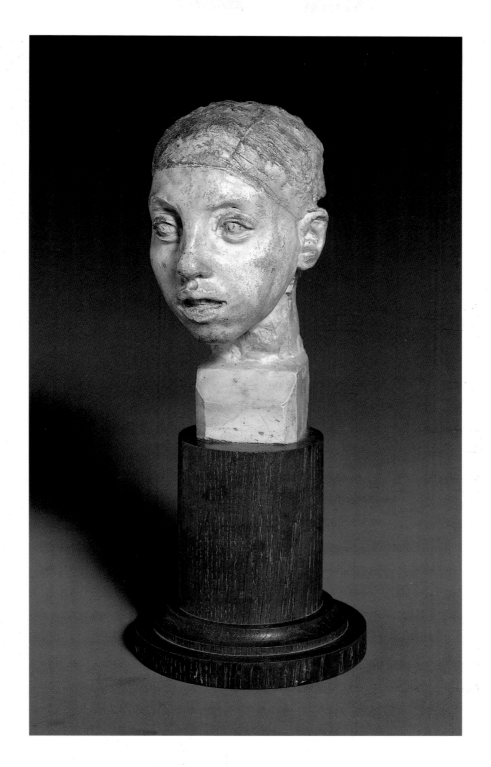

12.
Etude de tête d'enfant
Study of the head of a child
ca. 1895
Plaster, height: 7 7/8 in.
Private collection

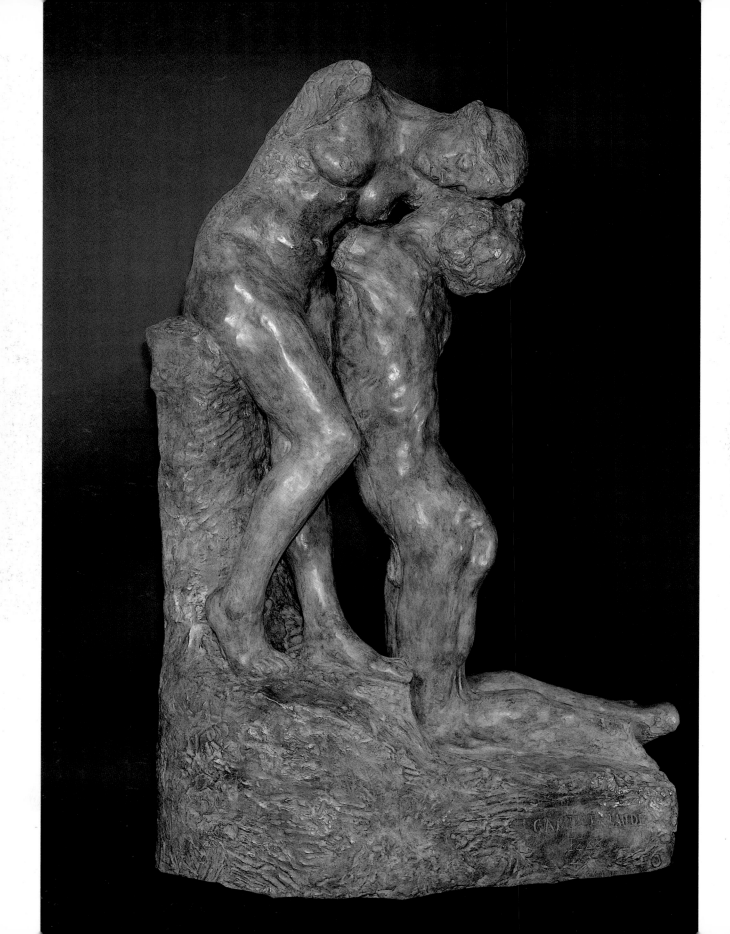

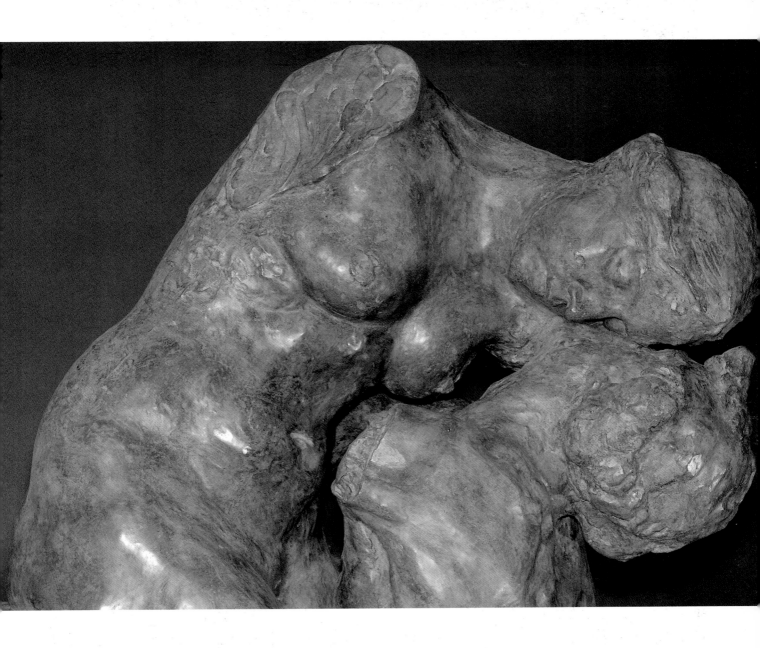

13.
Sakountala
1987
Bronze, 74 7/8×43 3/8×23 5/8 in.
Private collection

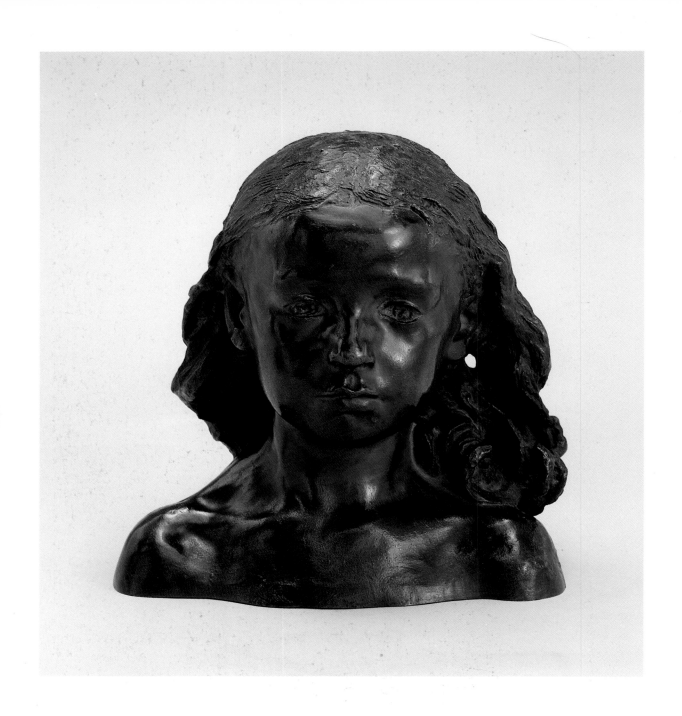

14.
Buste de Charles Lhermitte
Bust of Charles Lhermitte
1895
Bronze, 11 7/8×11 7/8×9 in.
Private collection

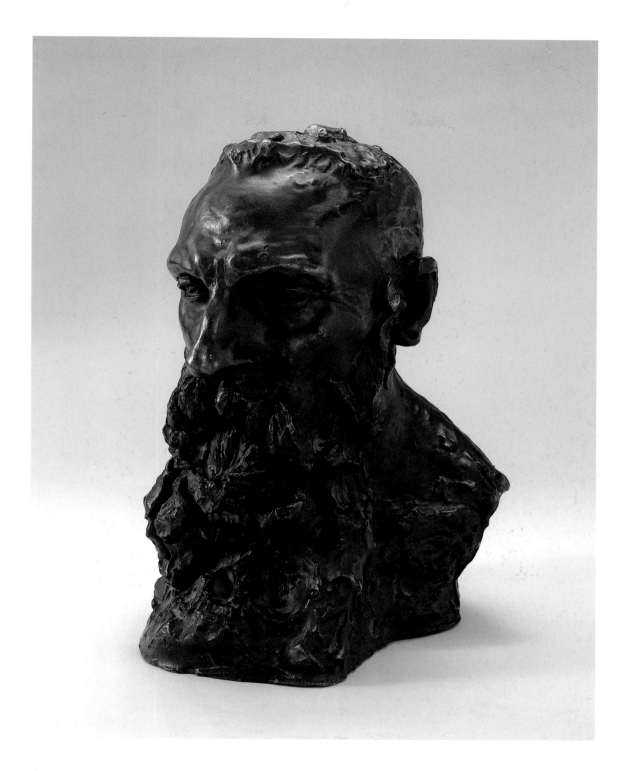

15.
Buste d'Auguste Rodin
Bust of Auguste Rodin
1892
Bronze, 15 3/4×9 7/8×11 in.
Alfred Baud, Geneva

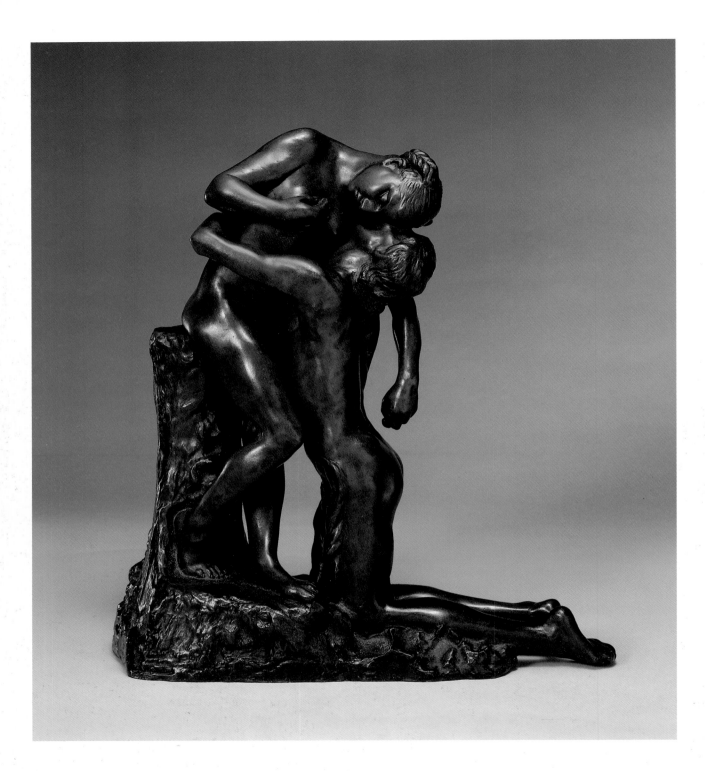

16.
L'Abandon
Abandonment
1888-1905
Bronze, 17×14 1/8×7 1/2 in.
Private collection

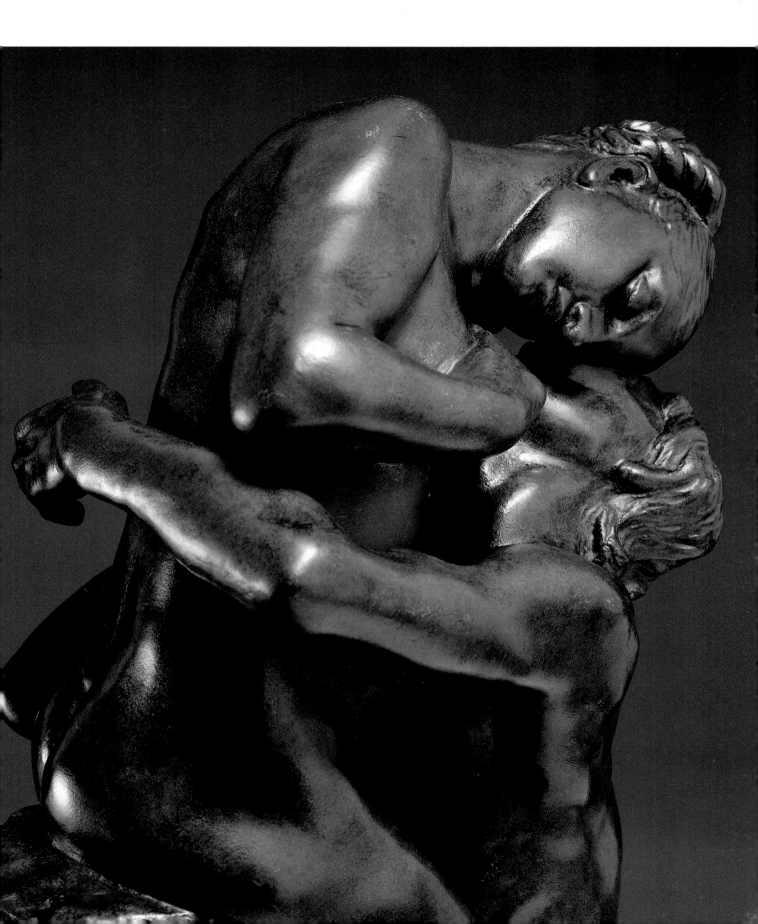

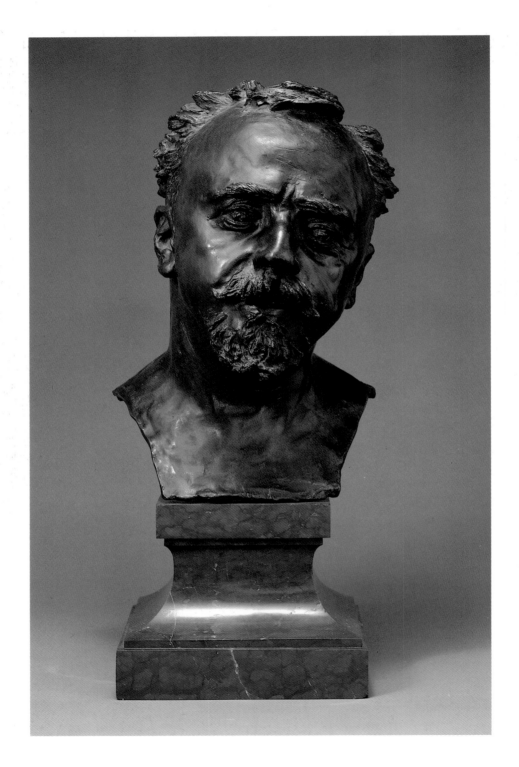

17.
Buste de Léon Lhermitte
Bust of Léon Lhermitte
1893–1895
Bronze, 13 3/4×9 7/8×9 7/8 in.
Private collection

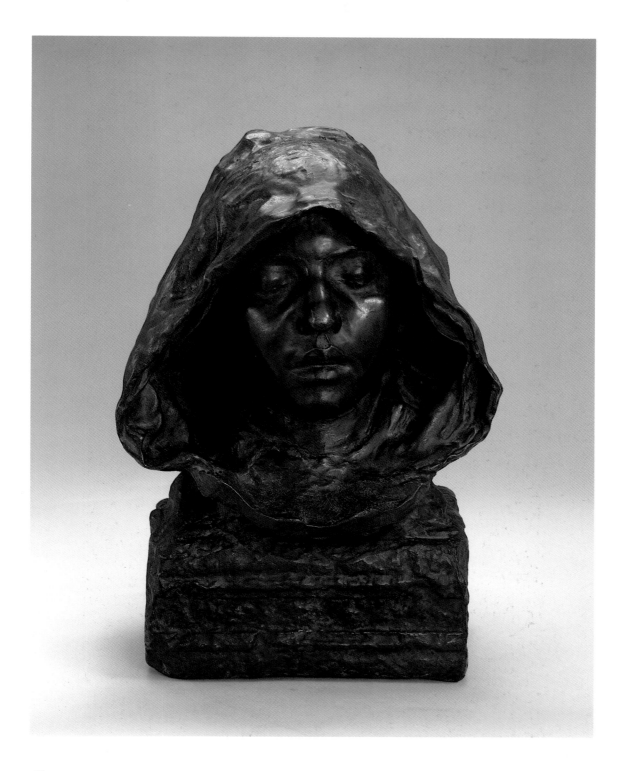

18.
Psaume ou ***La Prière*** ou ***Buste de femme au capuchon***
Psalm or The prayer or Bust of a lady with a hood
1889
Bronze, 17 3/4×12 1/4 in., 2×15 in.
Musée Boucher de Perthes, Abbeville

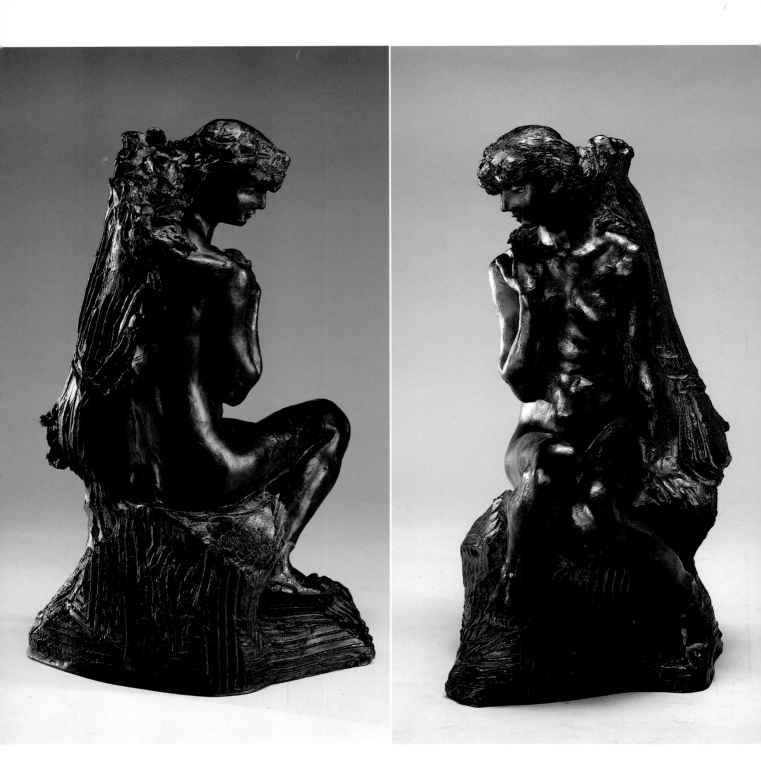

19.
Jeune fille à la gerbe
Young girl with a sheaf
1983
Bronze, 14 1/8×8 1/4×8 1/4 in.
Private collection

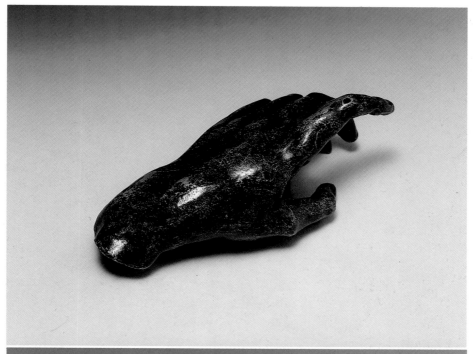

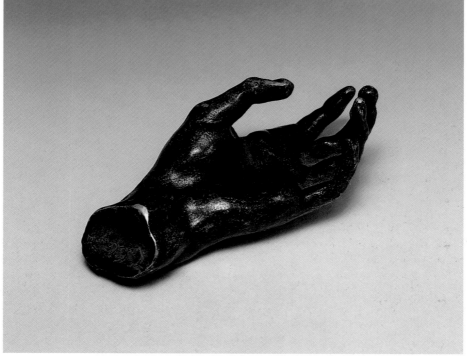

20.
Main
Hand
ca. 1885
Bronze, height: 2 in.
Private collection

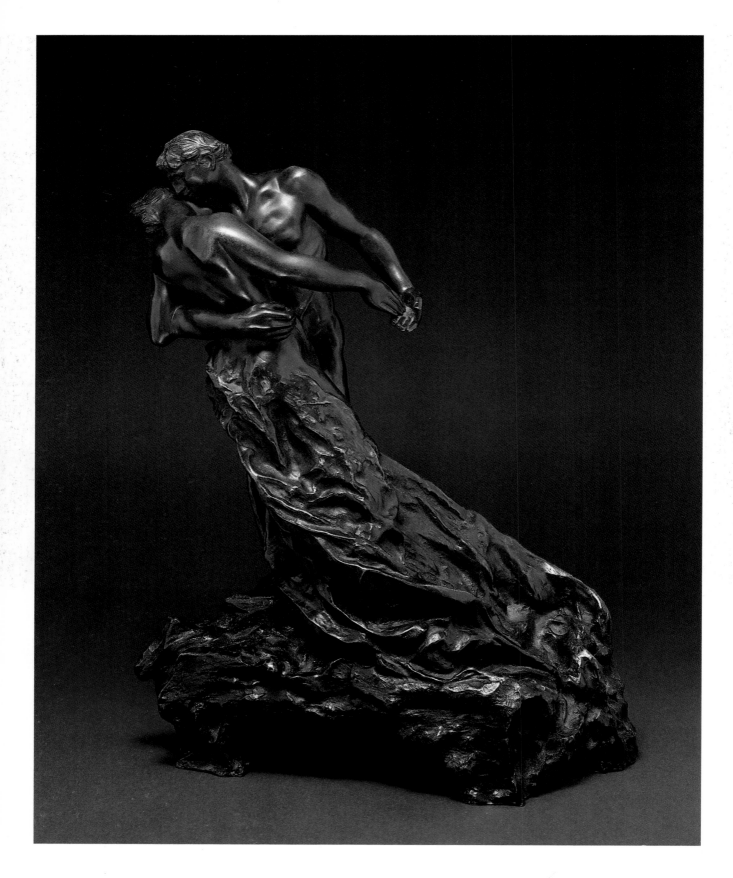

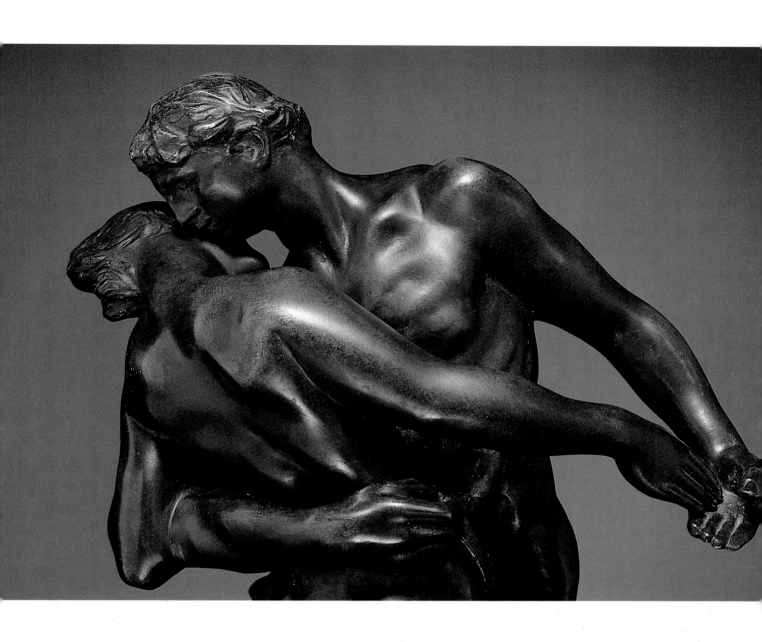

21.
La Valse
The waltz
1891–1905
Bronze, 18 1/8 in., 1 1/2×13×7 1/2 in., 2 3/4 in.
Private collection

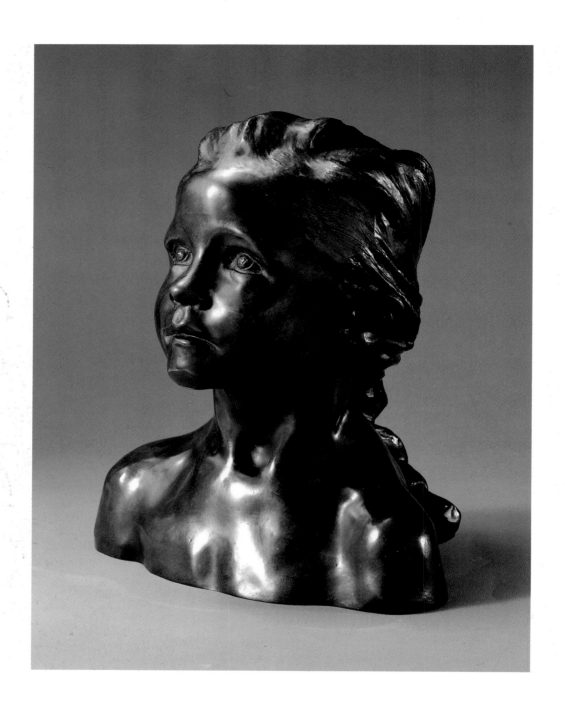

22.
La Petite châtelaine
The little mistress
1893–1894
Bronze, 13×11×8 5/8 in.
Private collection

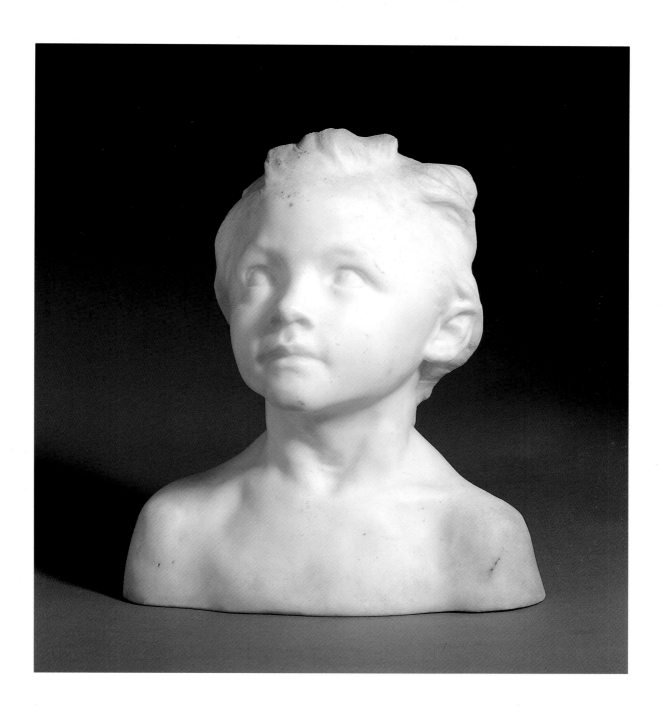

23.
La Petite châtelaine
The little mistress
1896
Marble, 17 3/8×9 7/8×13 3/4 in.
Private collection

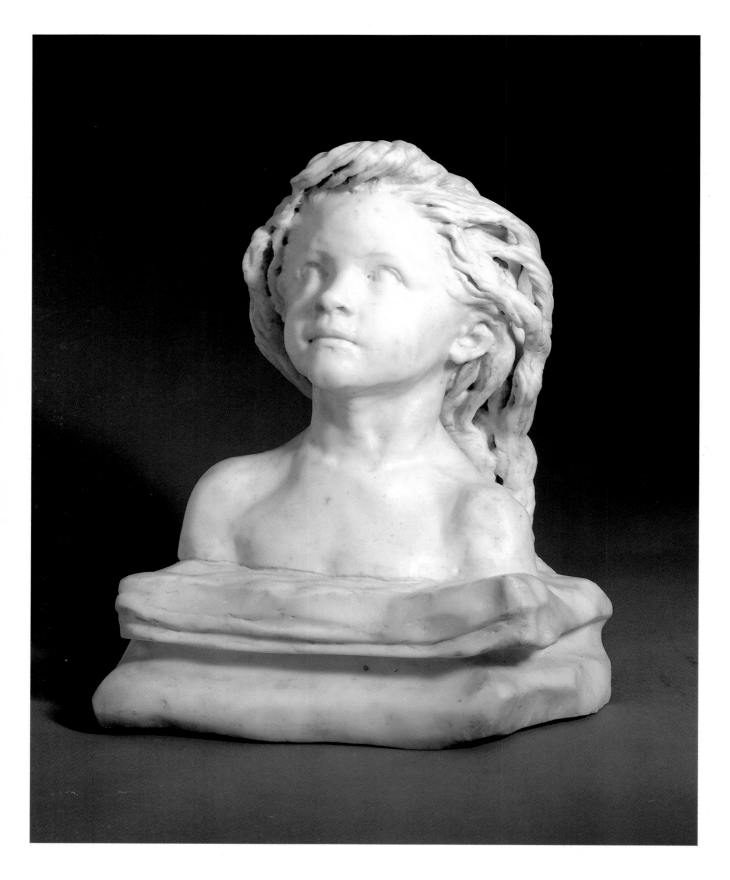

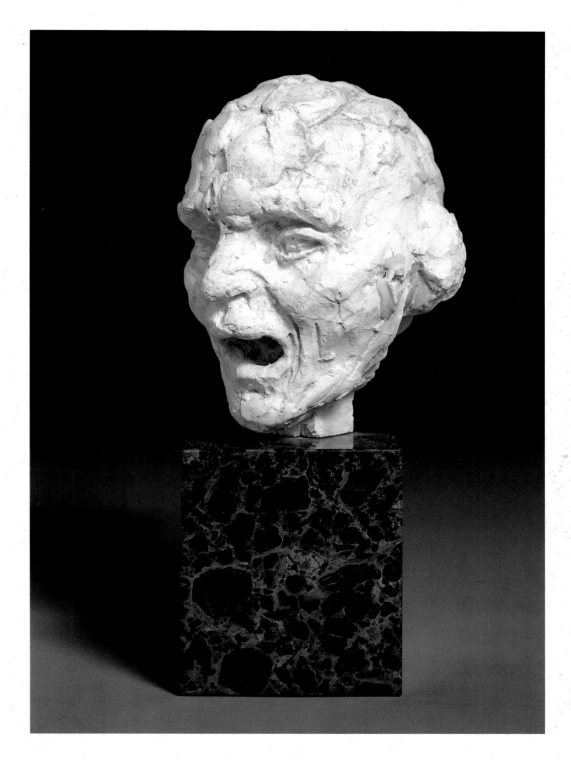

24.
La Petite châtelaine
The little mistress
1896
Marble, 17 3/8×13 3/8×11 7/8 in.
Private collection

25.
Tête de vieil aveugle chantant
Head of an old blindman singing
1894
Plaster, height: 7 7/8 in.
Private collection

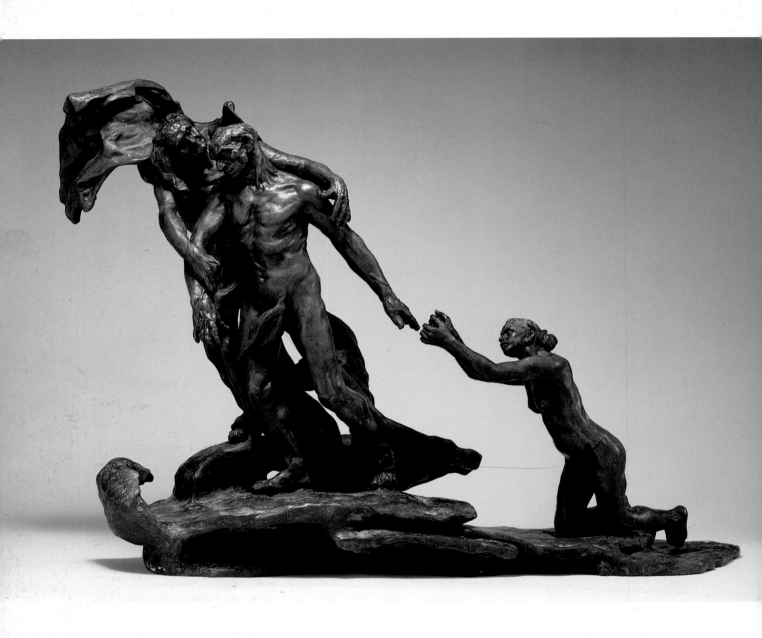

26.
L'Age mûr
Maturity
1907
Bronze, 31 1/2×21 5/8×13 in.
Private collection

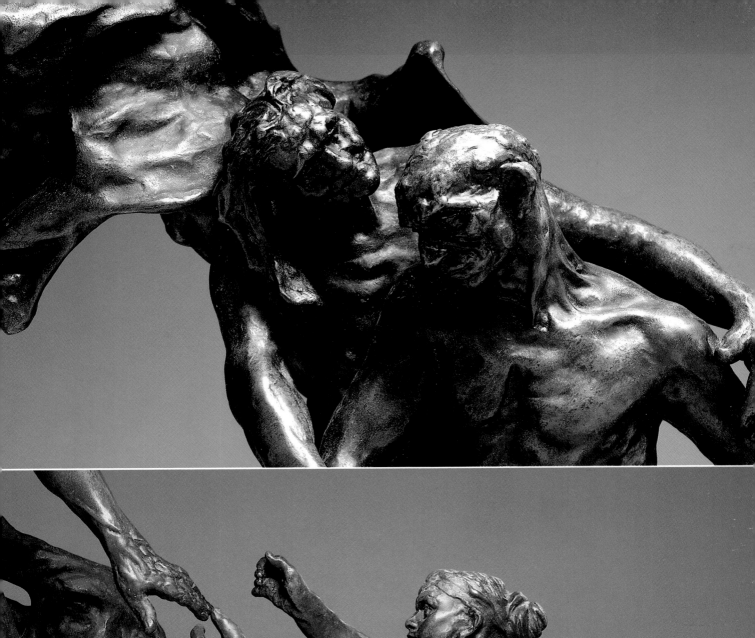
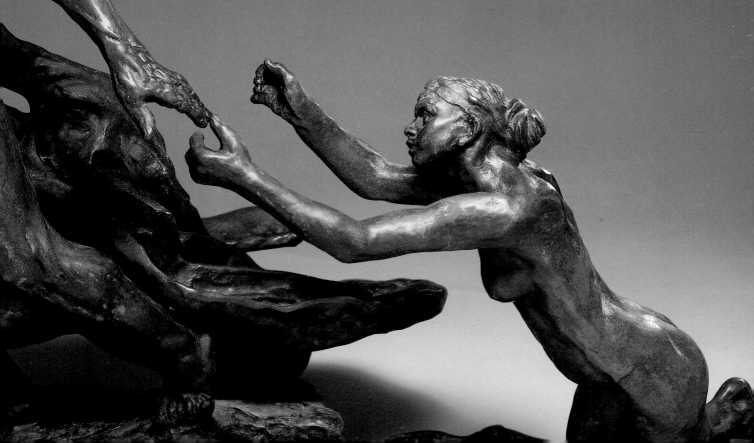

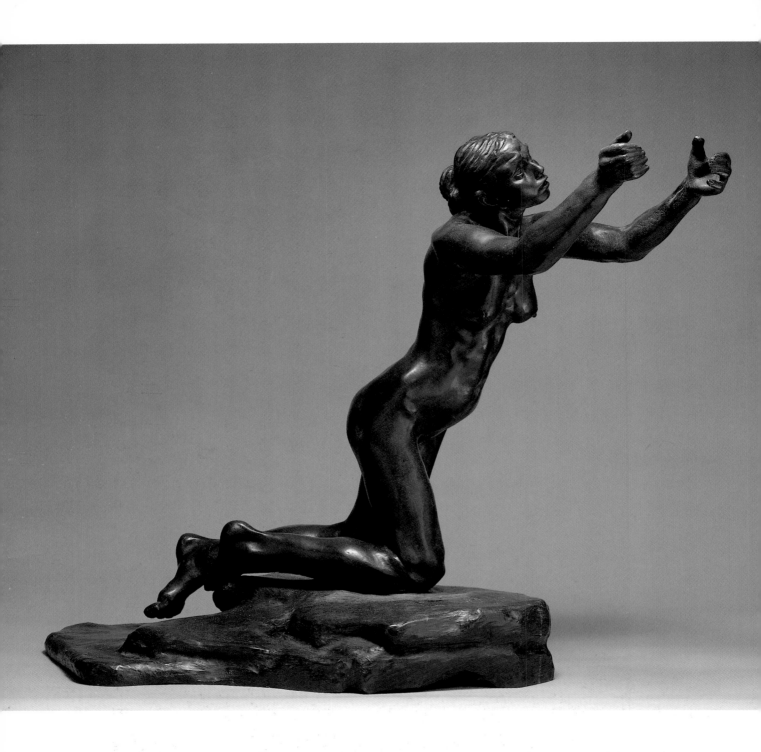

27.
L'Implorante
The implorer
1905
Bronze, 24 3/8×26×14 5/8 in.
Private collection

28.
Le Dieu envolé
God flown away
Bronze, 28 3/8×22×15 in.
Private collection

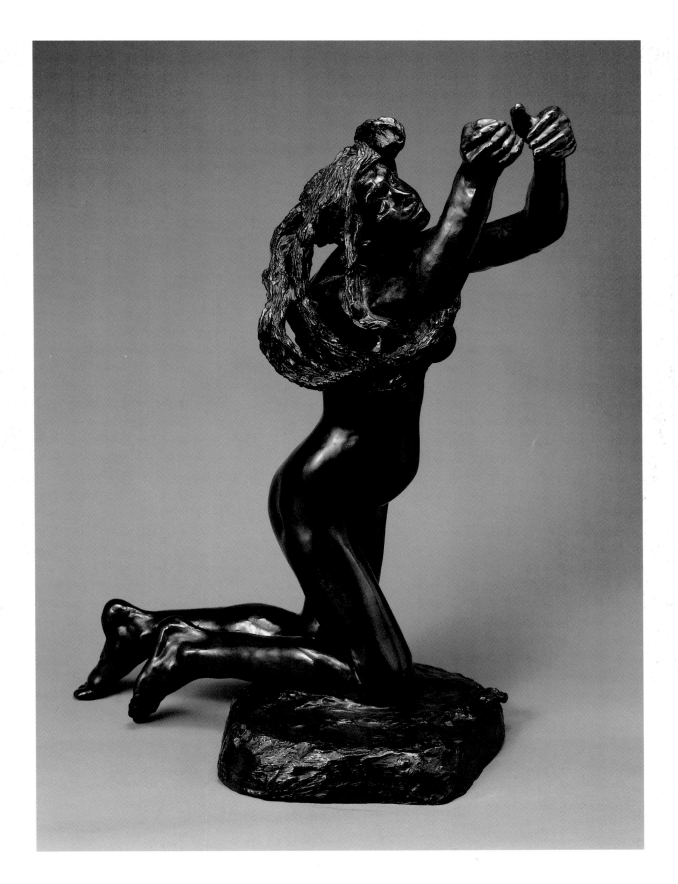

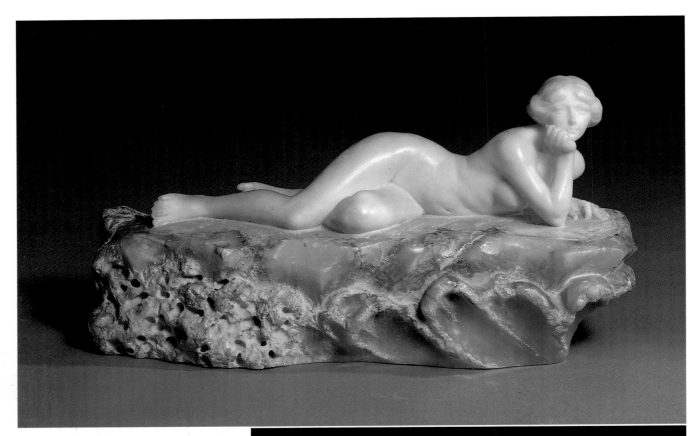

29.
L'Ecume
The foam
1897
Marble and onyx, 9 in., 2×15 3/4×6 in.
Private collection

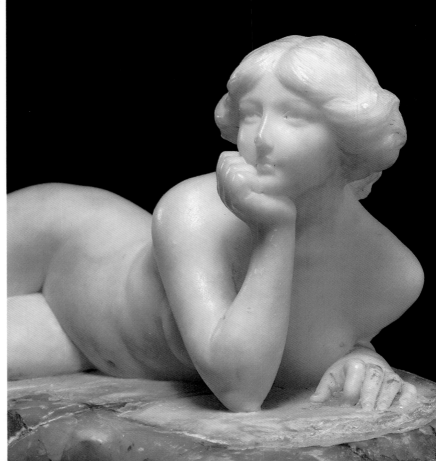

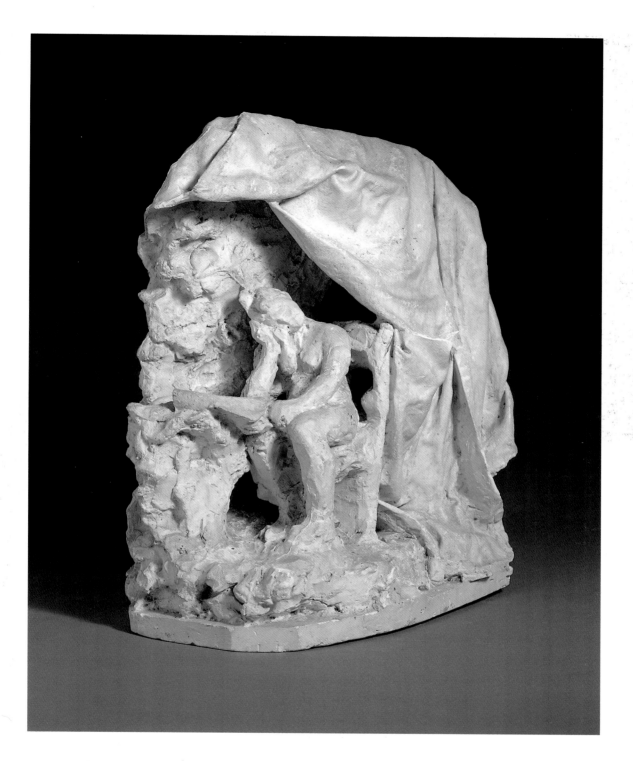

30.
Femme à sa toilette
Woman at her dressing table
ca. 1895–1897
Plaster, 15 3/8×14 1/8×10 5/8 in.
Private collection

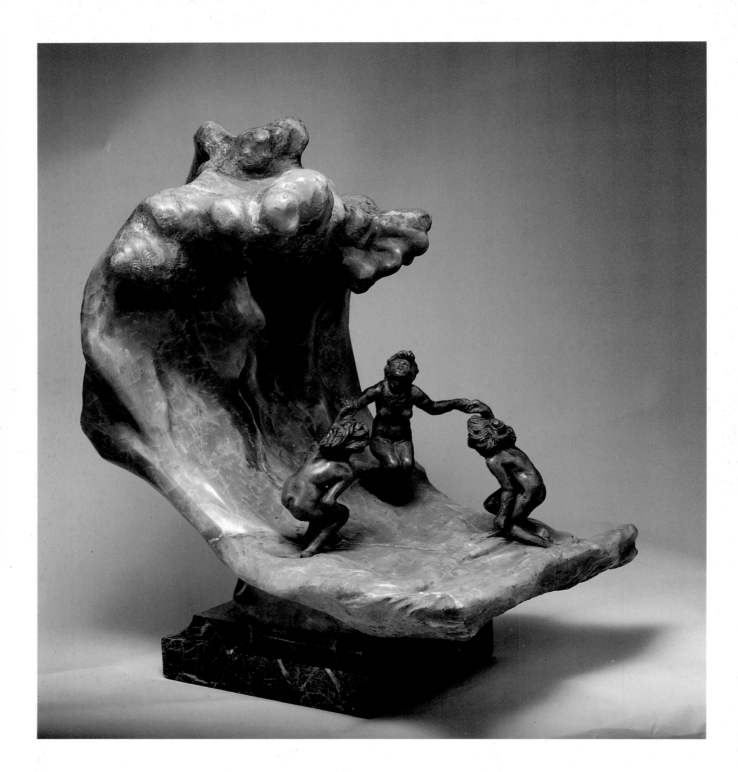

31.
La Vague
The wave
1897–1898
Bronze and onyx, 24 3/8×22×19 3/4 in.
Private collection

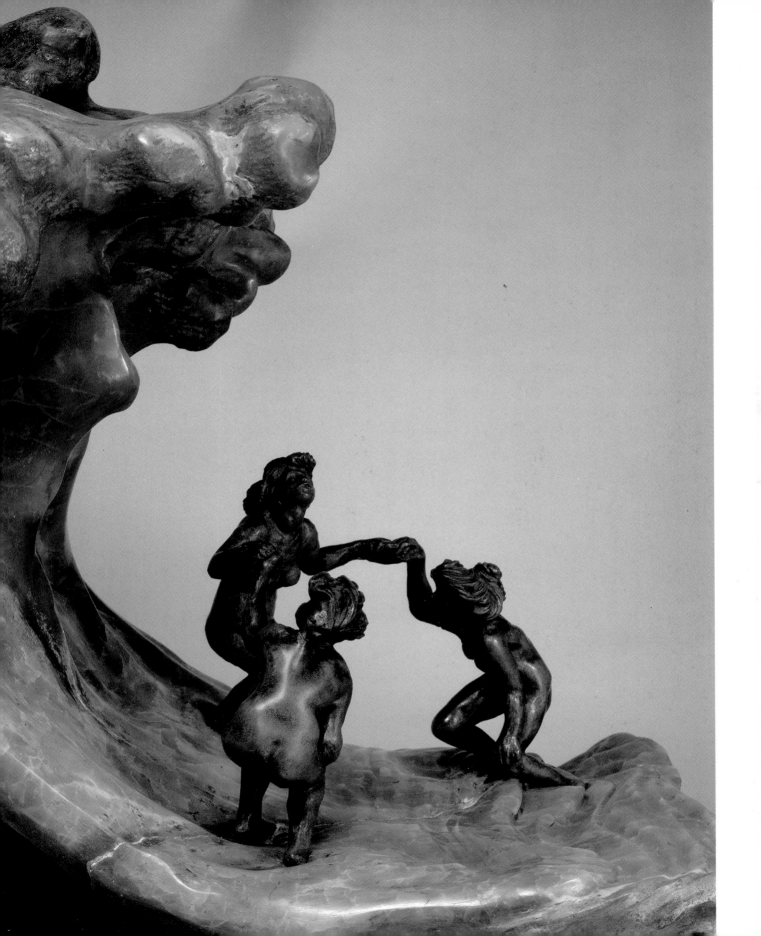

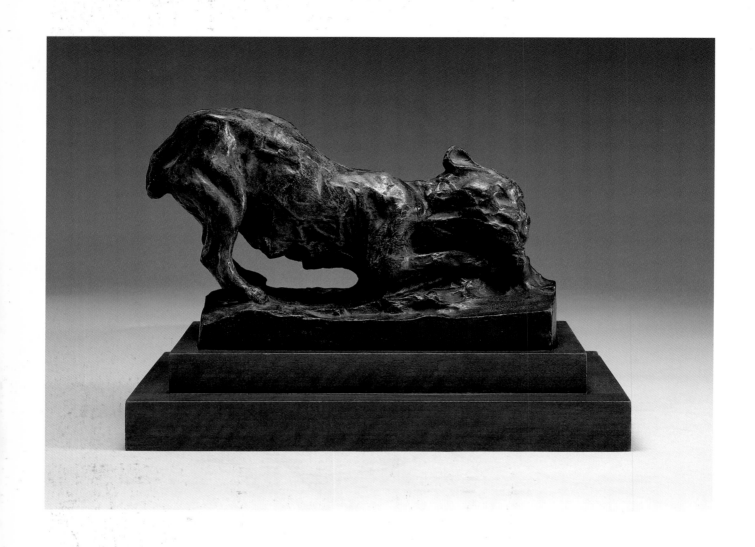

32.
Chien rongeant son os
Dog gnawing a bone
1898
Bronze, 6 3/8×8 5/8×4 in.
Private collection

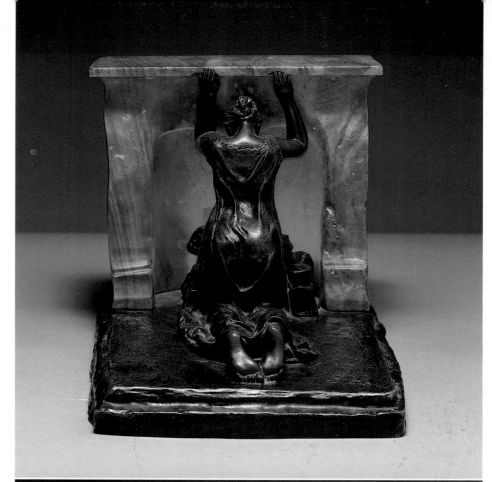

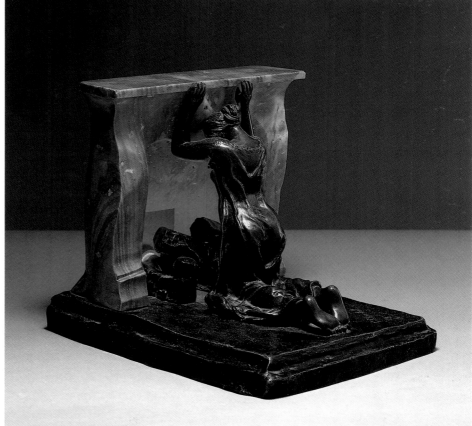

33.
La Profonde pensée ou *Femme*
agenouillée devant une cheminée
Deep thought or Woman kneeling
in front of a fireplace
1905
Bronze and onyx with lamp,
9 1/2×8 5/8×10 5/8 in., 2 in.
Private collection

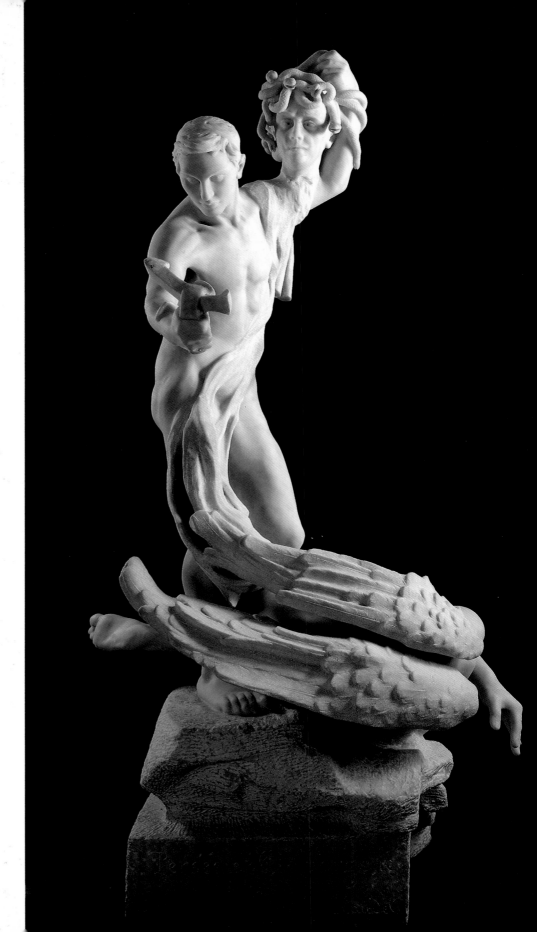

34.
Persée et la Gorgone
Perseus and the Gorgon
1898–1902
Marble, 77 1/4×43 3/4×39 in.
Private collection

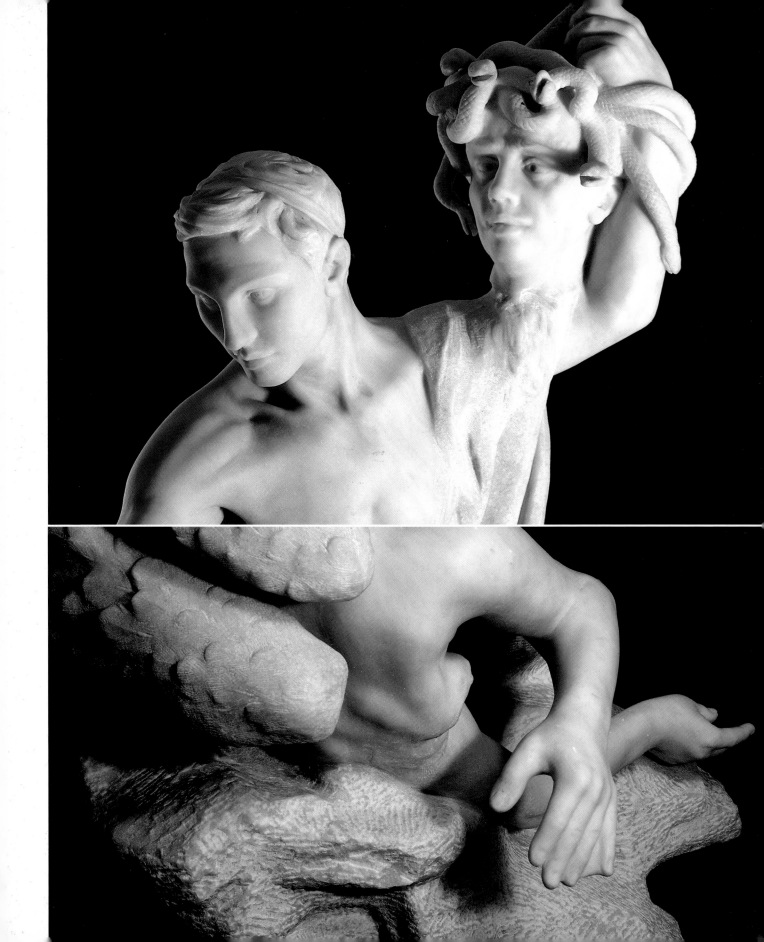

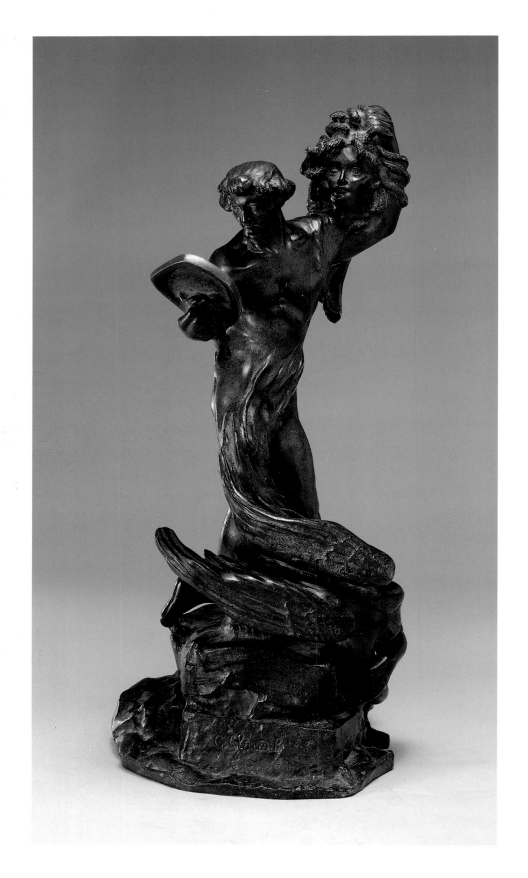

35.
Persée et la Gorgone
Perseus and the Gorgone
1898–1905
Bronze, 20×11 3/4×9 3/4 in.
Private collection

36.
L'Homme aux bras croisés
Man with crossed arms
ca. 1885
Terra cotta, 4×3 1/2 in., 2×3 1/8 in.
Private collection

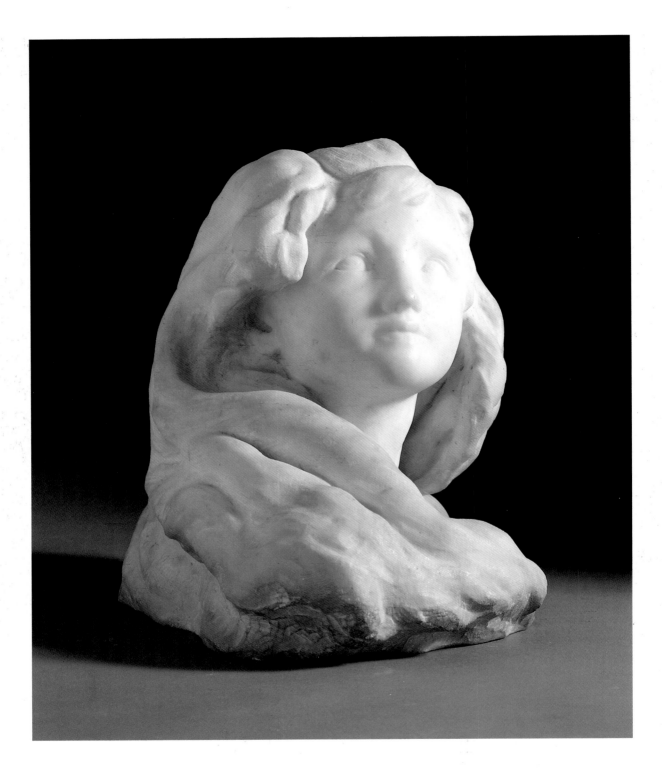

37.
L'Aurore
The dawn
1905
Marble, 13 3/4×11 3/8×11 7/8 in.
Private collection

38.
La Fortune
The fortune
1905
Bronze, 18 7/8×13 3/4×6 3/4 in., 2 in.
Private collection

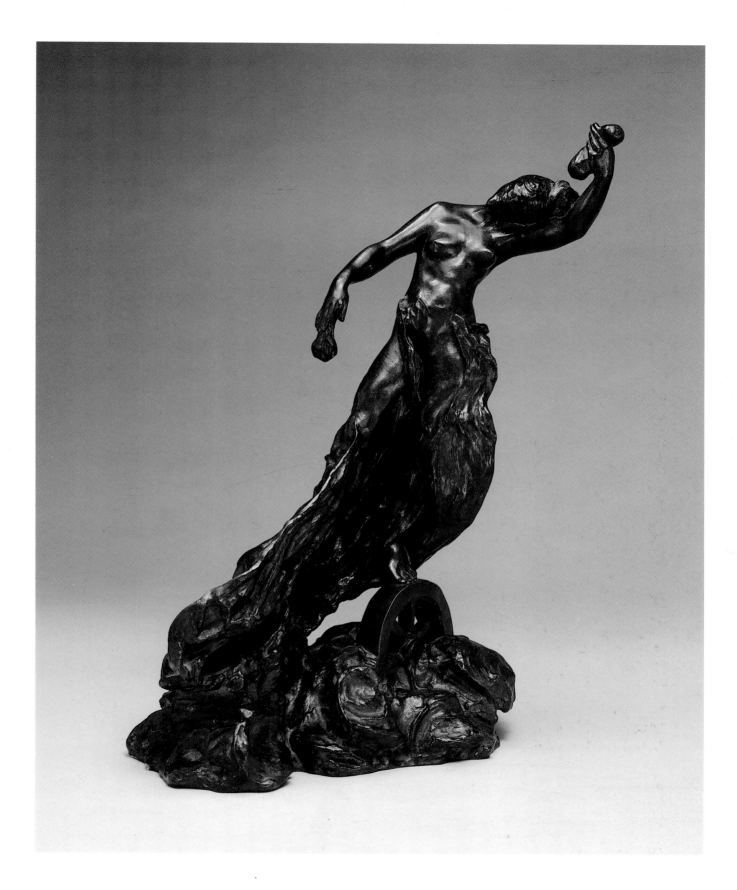

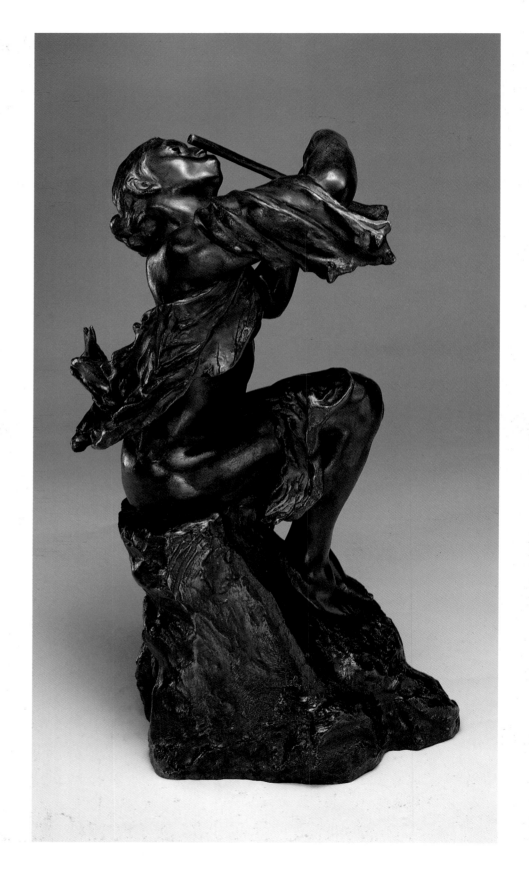

39.
La Joueuse de flûte
The flute player
1900–1905
Bronze, 13×7 7/8×12 1/4 in.
Private collection

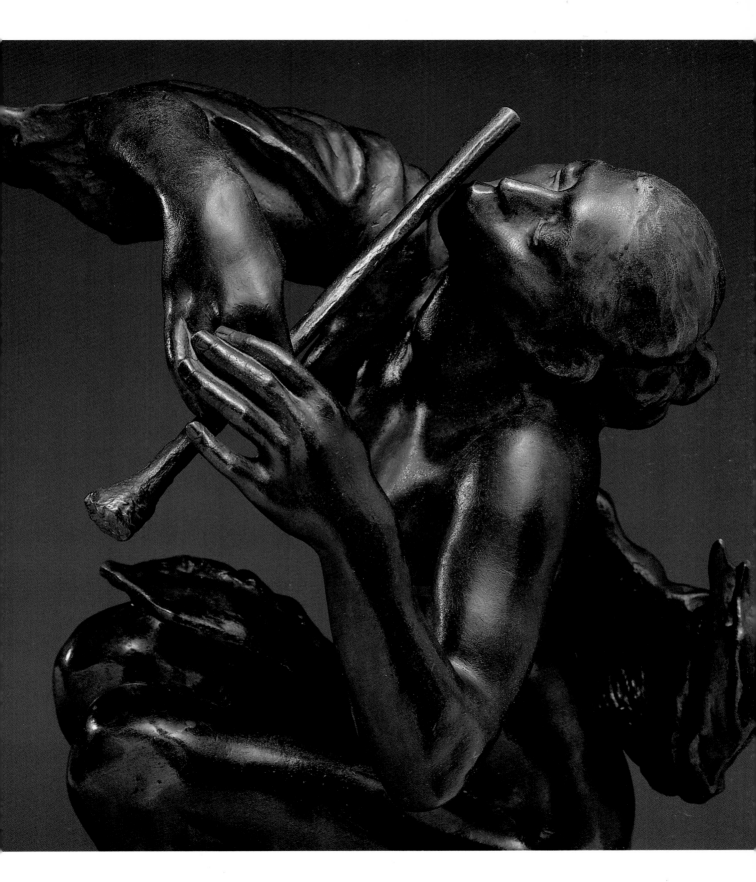

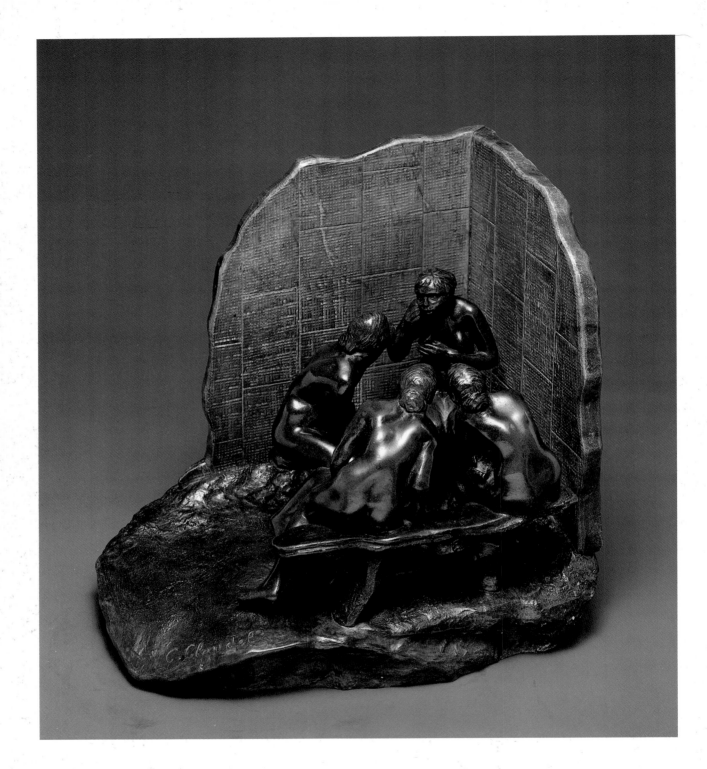

40.
Les Causeuses
The gossips
1893-1905
Bronze and marble, 13×7 7/8×12 1/4 in.
Private collection

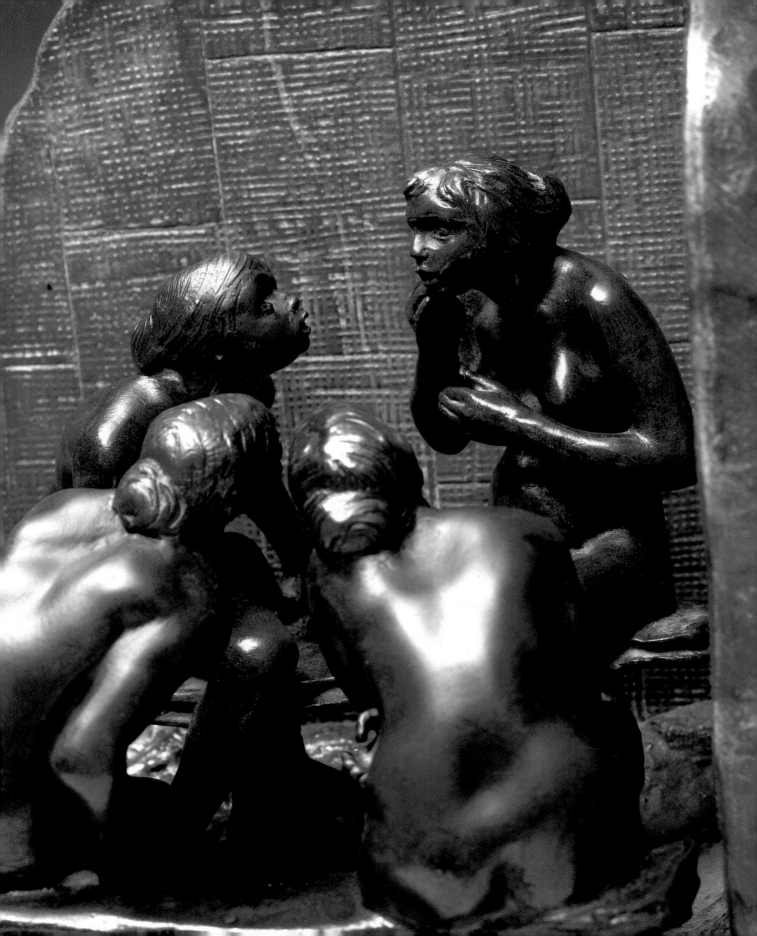

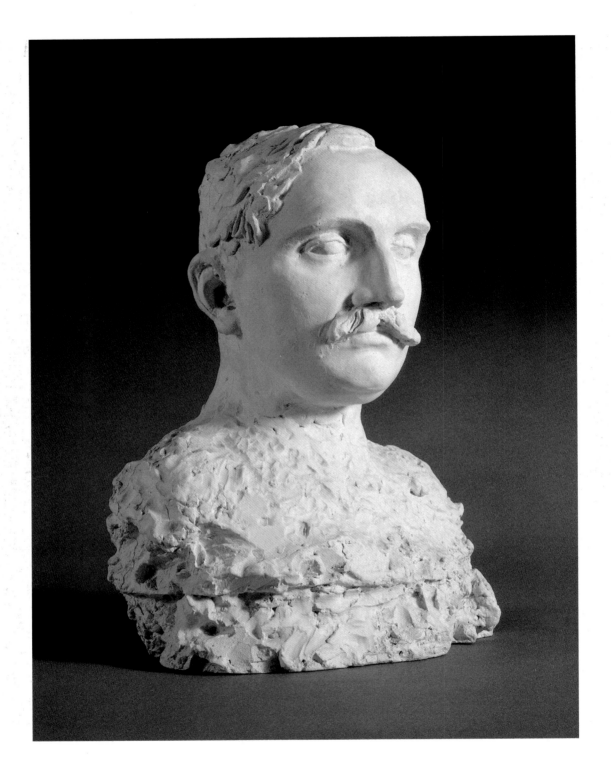

41.
Buste de Paul Claudel à trente-sept ans
Bust of Paul Claudel at thirty-seven
1905
Plaster, height: 11 7/8 in.
Private collection

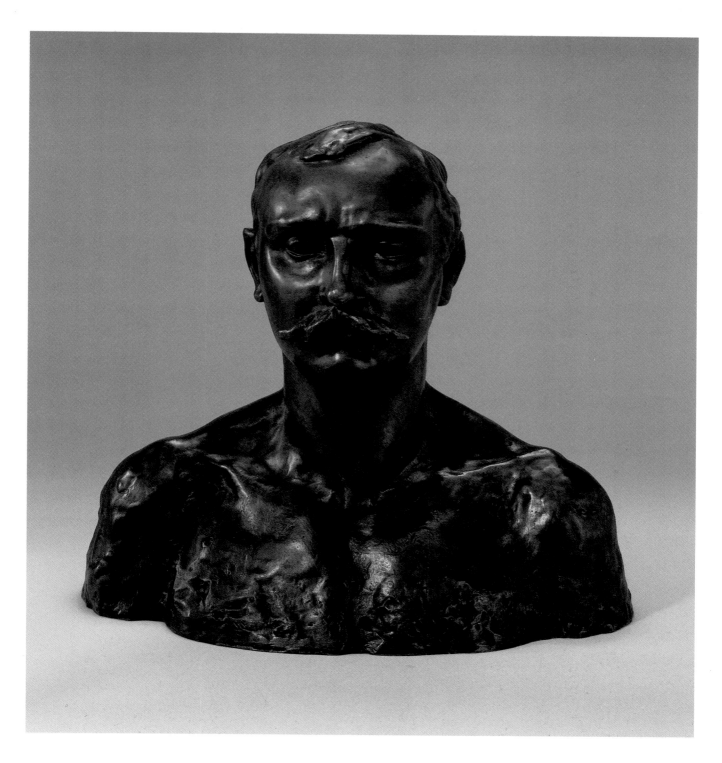

42.
Buste de Paul Claudel à quarante-deux ans
Bust of Paul Claudel at forty-two
1910
Bronze, 18 7/8×20 1/2×12 1/4 in.
Private collection

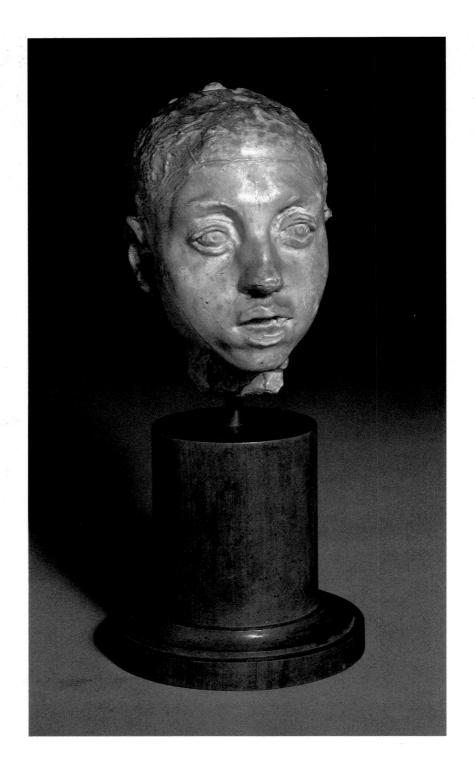

43.
Etude de tête d'enfant
Study of the head of a child
ca. 1895
Plaster, height: 7 7/8 in.
Private collection

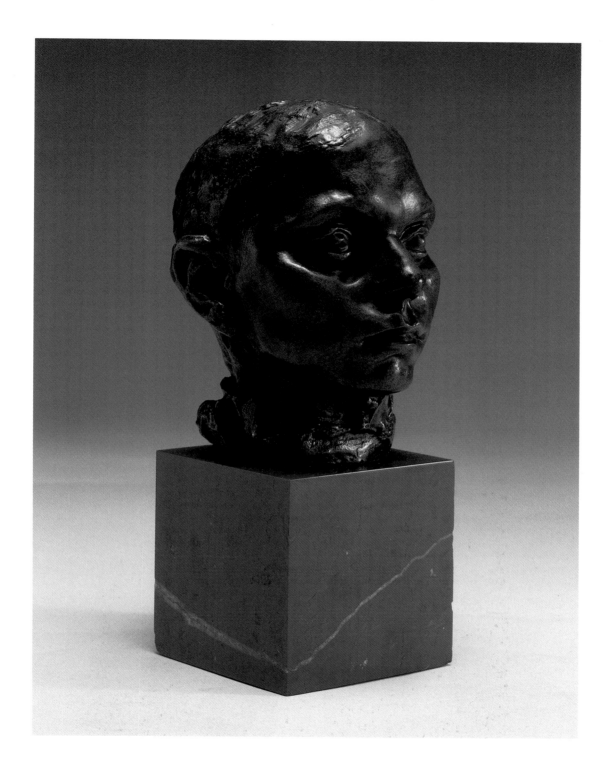

44.
Etude de tête d'enfant
Study of the head of a child
Before 1913
Bronze, 9 7/8×3 1/8×3 1/8 in.
Private collection

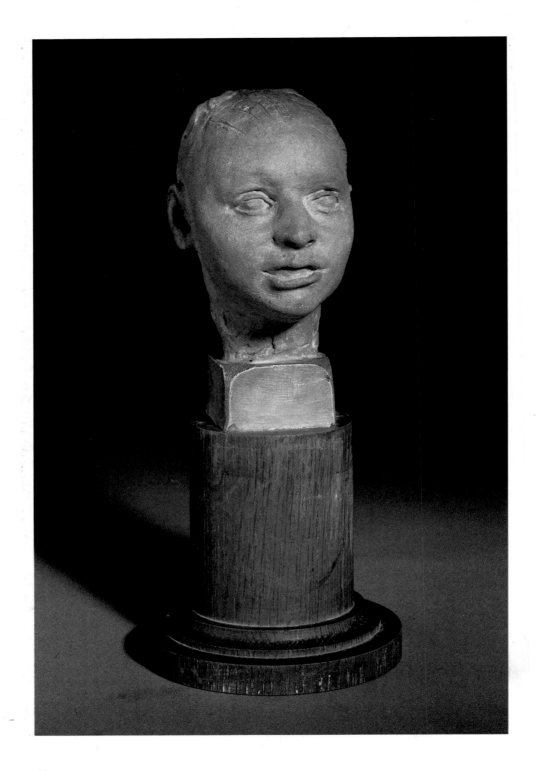

45.
Etude de tête de jeune fille au chignon
Study of the head of a young girl with a chignon
Before 1913
Terra cotta, 11 7/8×4 3/8×4 3/4 in.
Private collection

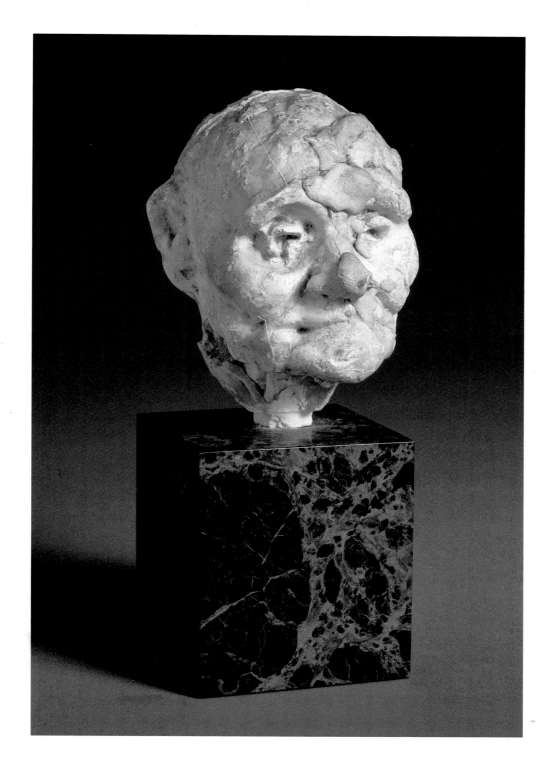

46.
Tête de vieille femme
Head of an old woman
Before 1913
Plaster, height: 7 7/8 in.
Private collection

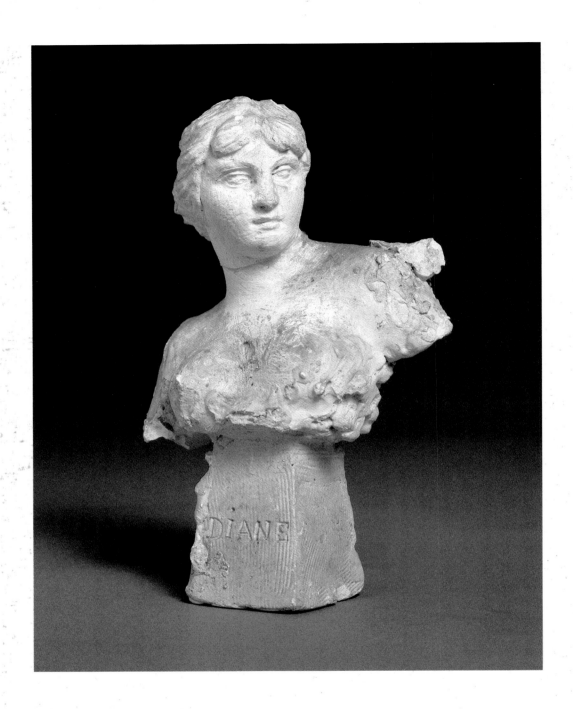

47.
Diane
Plaster, height: 7 7/8 in.
Private collection

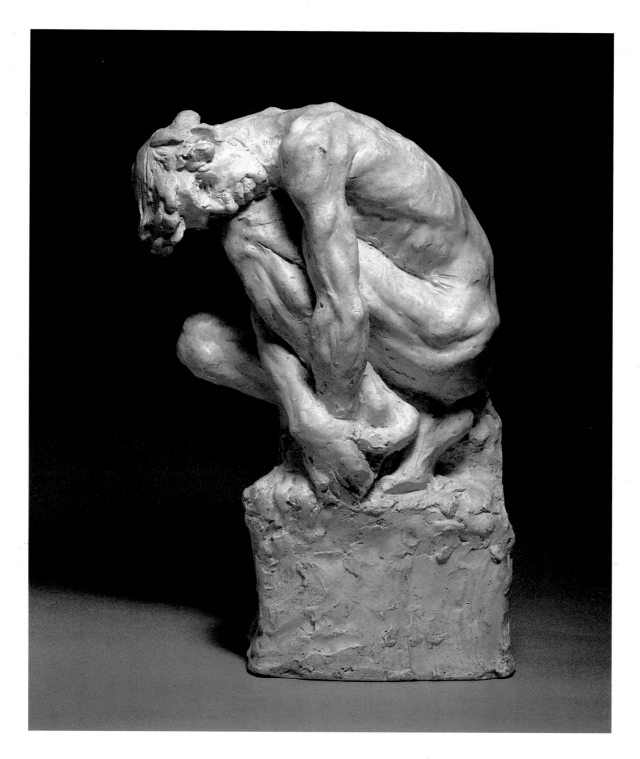

48.
L'Homme penché
The man bending over
1886
Plaster, 16 1/2×6 3/4×9 7/8 in.
Private collection

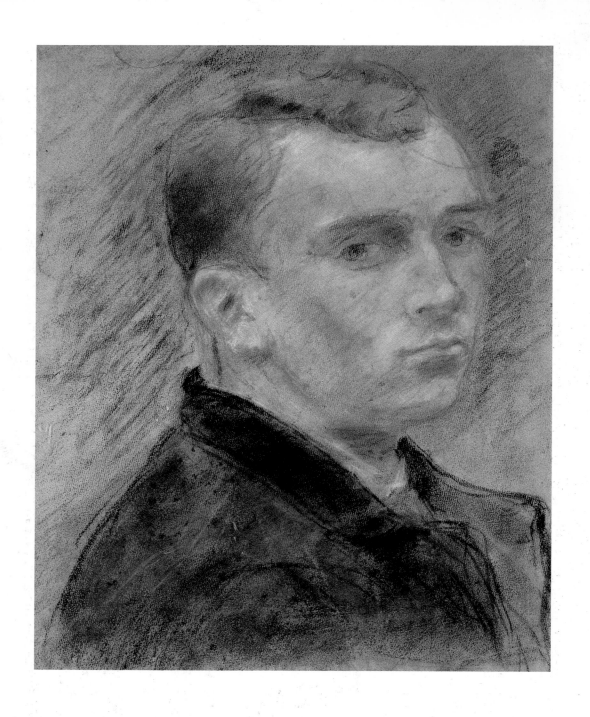

49.
Portrait de Paul Claudel à vingt ans
Portrait of Paul Claudel at twenty
1888
Pastel, 17×13 3/4 in.
Private collection

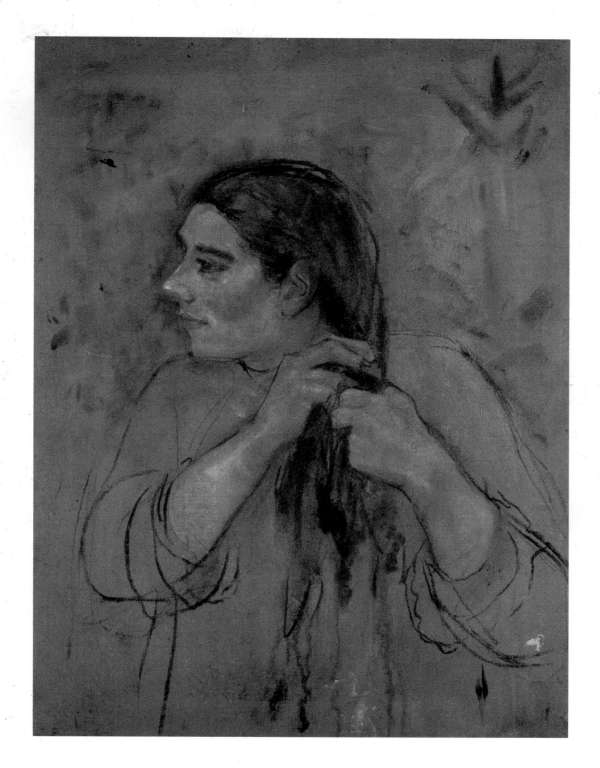

50.
Portrait de Maria Paillette
Portrait of Maria Paillette
1887
Oil on canvas, 31 1/2×23 1/4 in.
Private collection

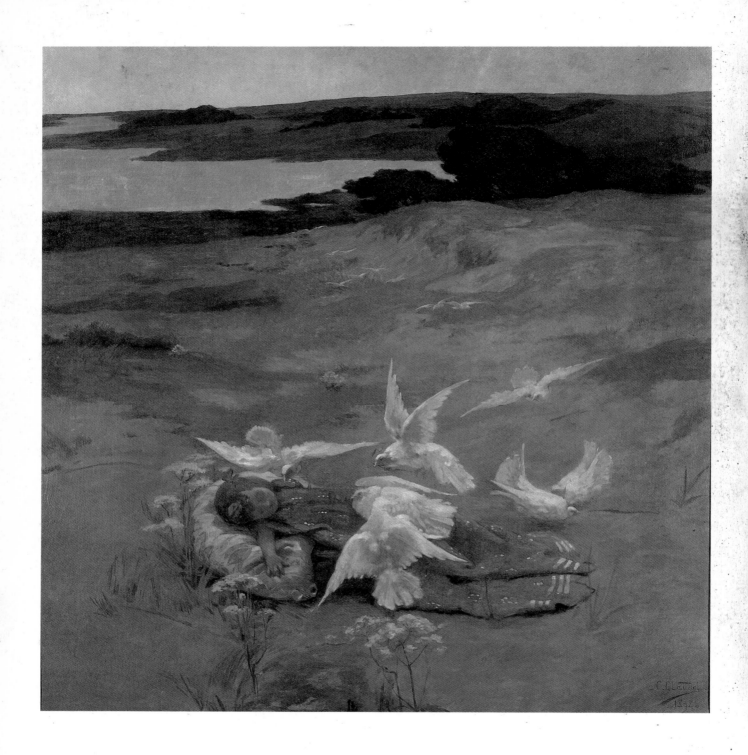

51.
Petite fille aux colombes
Little girl with doves
1898
Oil on canvas, 49 1/4×51 1/4 in.
Private collection

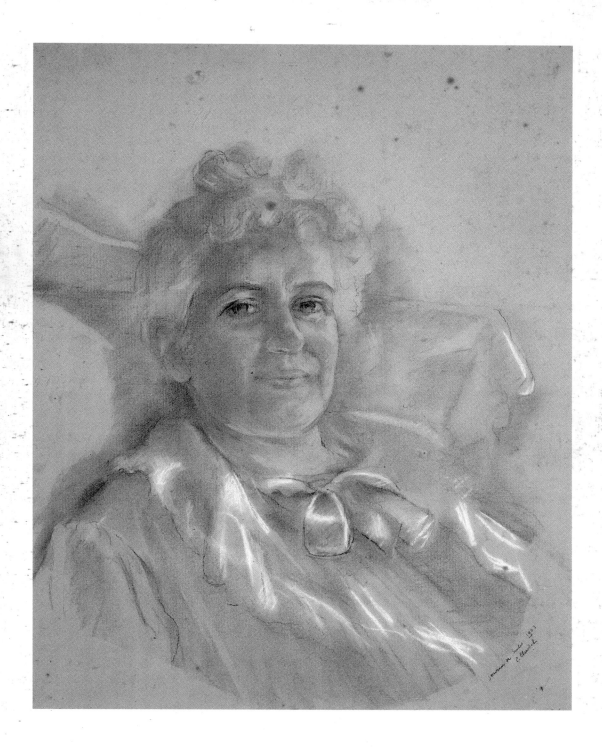

52.
Portrait de Madame de Maigret
Portrait of Madame de Maigret
1903
Charcoal, chalk and pastel on paper,
20 7/8×26 in.
Musée Municipal, Château-Gontier

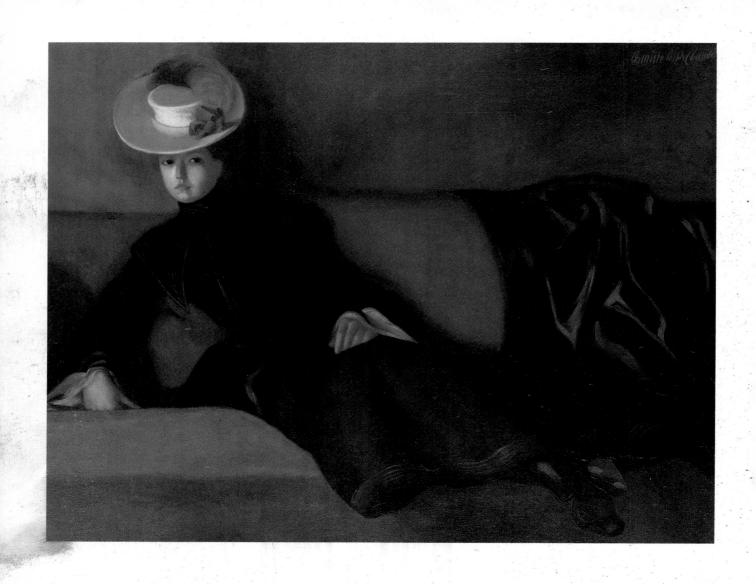

53.
Jeune femme au divan
Young woman on the sofa
1900
Oil on canvas, 28 3/4×36 1/4 in.
Private collection

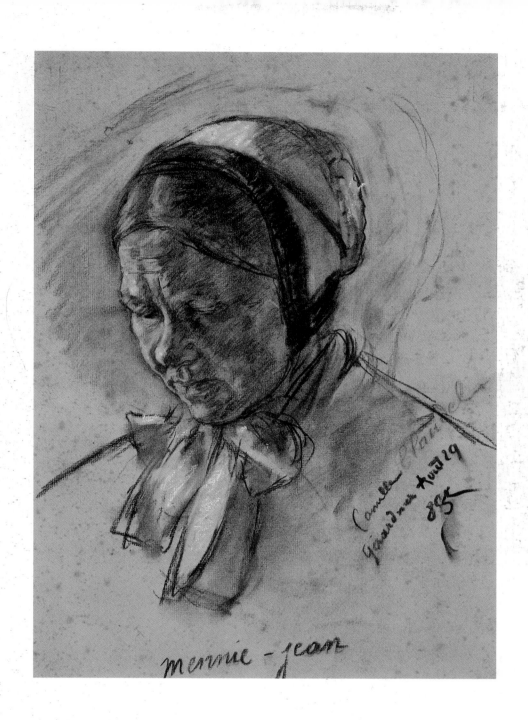

54.
Femme de Gerardmer
Woman from Gerardmer
1885
Charcoal and chalk on paper, 18 7/8×14 5/8 in.
Musée Eugène Boudin in Honfleur

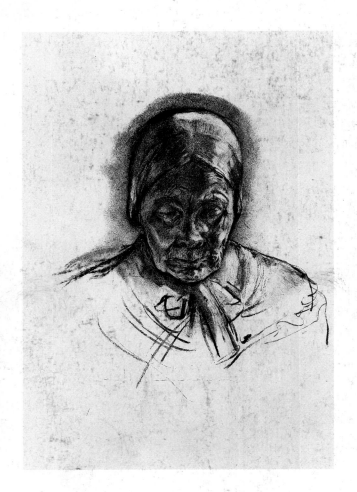

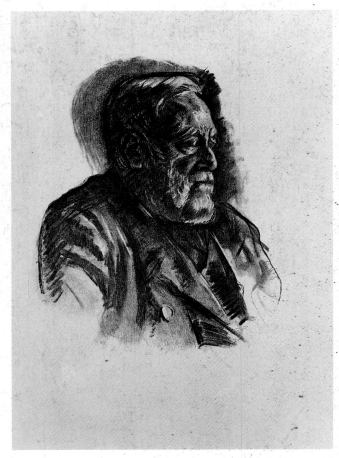

55.
A Quiet Nap
1886
Original reproduction of a charcoal drawing,
15×10 1/4 in.
Musée Archéologique de Laon

56.
Le docteur Jeans
Doctor Jeans
1886
Original reproduction of a charcoal drawing,
14 5/8 ×10 1/4 in.
Musée Archéologique de Laon

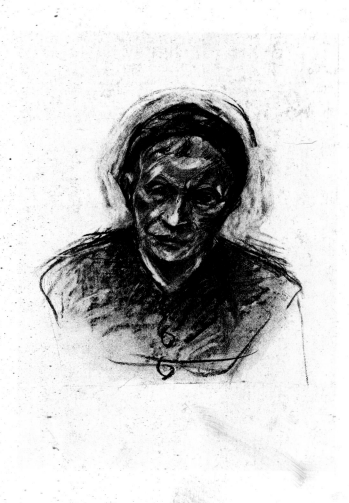

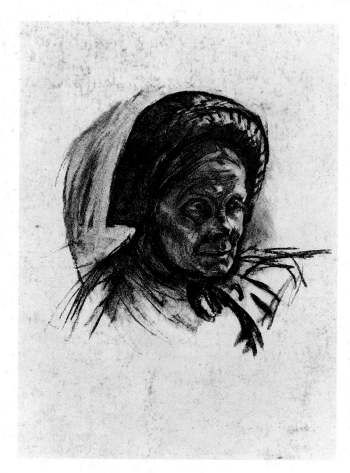

57.
A Fisher Woman
1886
Original reproduction of a charcoal drawing,
14 5/8×10 1/4 in.
Musée Archéologique de Laon

58.
Old Granny
1886
Original reproduction of a charcoal drawing,
15 3/8×10 3/4 in.
Musée Archéologique de Laon

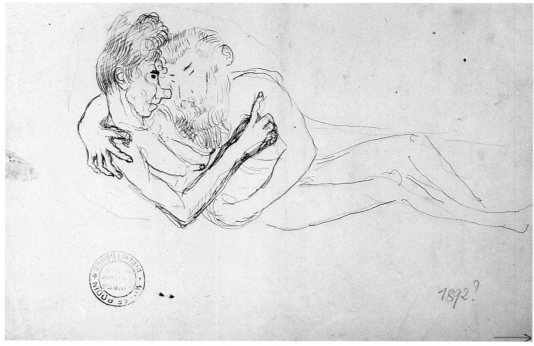

59.
Le Réveil ou *Douce remontrance*
The awakening or Sweet protest
1892?
Commissioned drawing
Facsimile of a pen and brown ink on paper, 7×10 1/2 in.
Musée Rodin, Paris

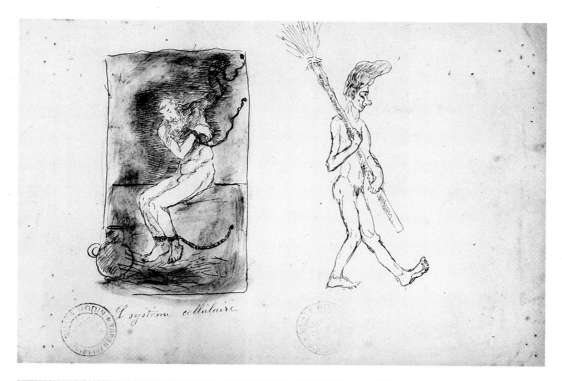

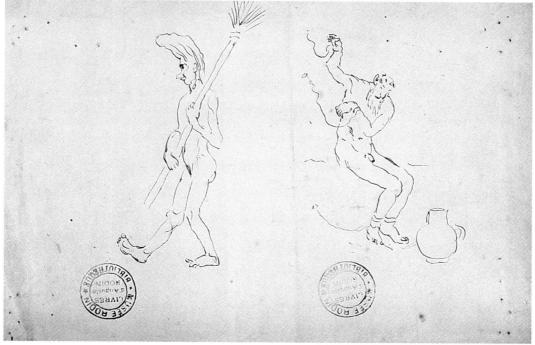

60.
Le Système cellulaire
Prison conditions
1892?
Facsimile of a pen and ink wash on paper, 7 1/4×10 3/4 in.
Musée Rodin, Paris

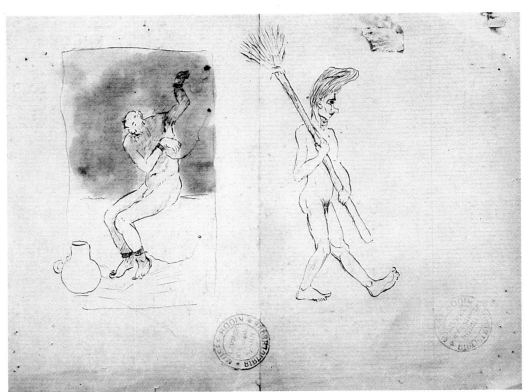

61.
Le Système cellulaire
Prison conditions
1892?
Facsimile of a pen and
ink wash, 7 1/4×10 3/4 in.
Musée Rodin, Paris

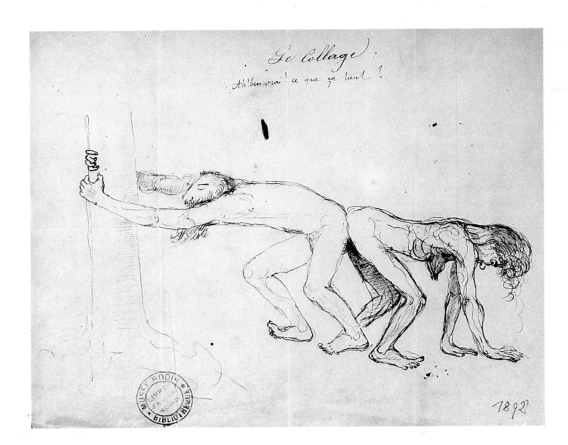

62.
Le Collage
Cohabitation
1892?
Facsimile of a pen and
brown ink on paper,
8 1/4×10 3/8 in.
Musée Rodin, Paris

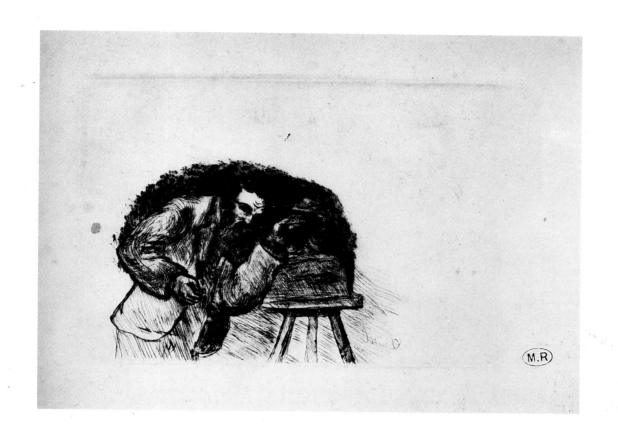

63.
Rodin sur le morceau
Rodin contemplating a fragment
1895–1896
Facsimile of a commissioned drawing,
7 7/8×10 1/8 in.
Musée Rodin, Paris

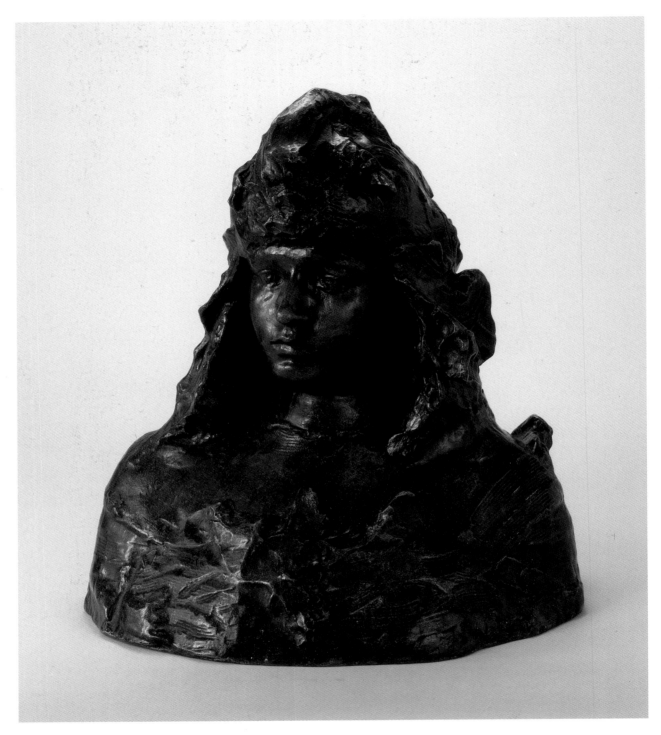

64.
La France
France
Auguste Rodin
1904
Bronze, 19 3/4×16 1/2×14 1/8 in.
Private collection

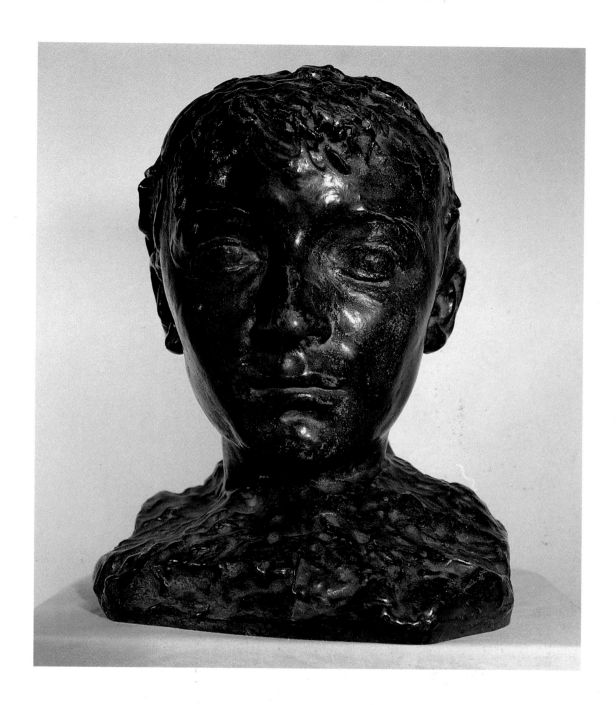

65.
Portrait de Camille Claudel
Portrait of Camille Claudel
Auguste Rodin
1884
Bronze, 10 1/2×8×8 3/8 in.
Musée Rodin, Paris, Inv. S. 1005
Photo: Eric Emo

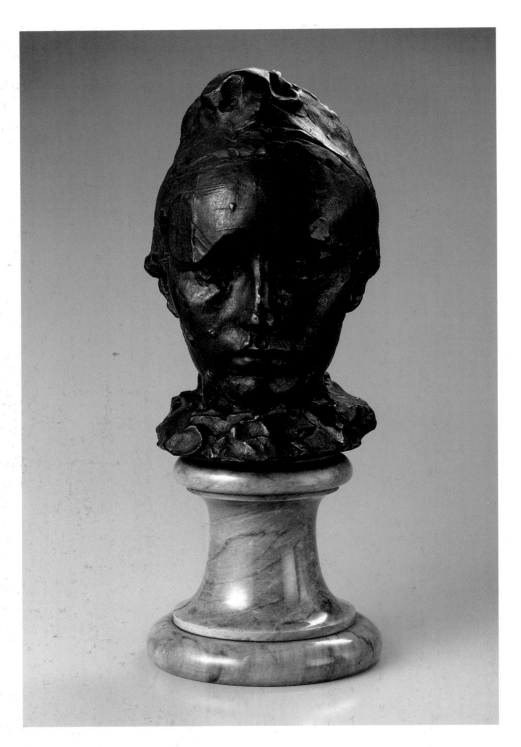

66.
Mademoiselle Camille Claudel
Auguste Rodin
1889
Bronze, height: 9 1/2 in.
Bridgestone Museum of Art,
Ishibashi Foundation, Tokyo

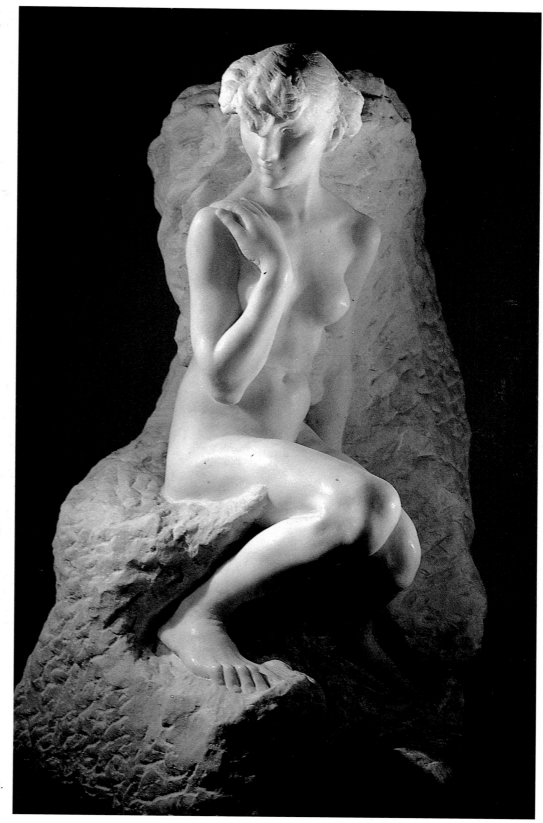

67.
Galatea
Auguste Rodin
ca. 1890
Marble, 24×16×15 3/8 in.
Musée Rodin, Paris,
Inv. S. 1110
Photo: Eric Emo

68.
Portrait d'une amie anglaise
Portrait of an English friend
1900
Oil on canvas, 25 1/4×21 1/4 in.
Private collection

69.
Vertumne et Pomone
Vertumnus and Pomona
1905
Marble, 35 7/8×31 1/2×16 1/8 in.
Musée Rodin, Paris, Inv. S. 1293
Photo: Bruno Jarret

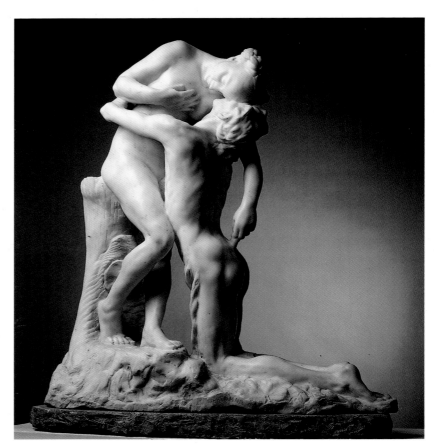

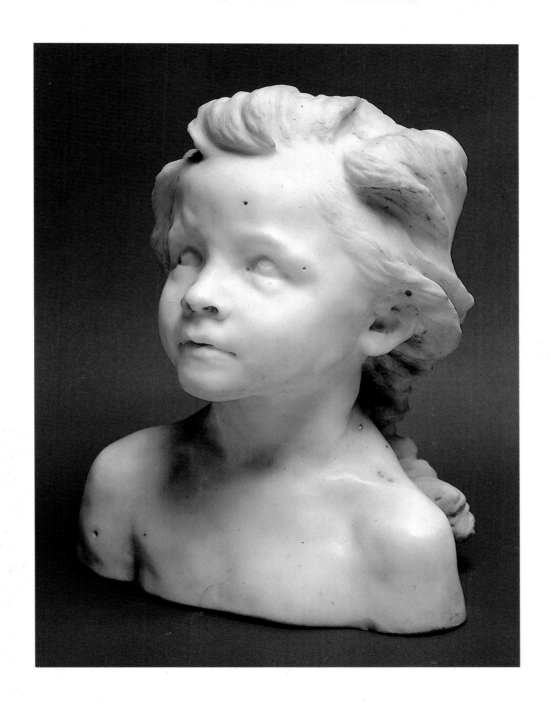

71.
La Petite châtelaine
The little mistress
Marble, 13 5/8×11 1/8×8 7/8 in.
Musée Rodin, Paris, Inv. S. 1007
Photo: Bruno Jarret

72.
L'Aurore
The dawn
Auguste Rodin
1885
Marble, 22 1/8×23 5/8×21 in.
Musée Rodin, Paris, Inv. S. 1019
Photo: Eric Emo

Chronology

1864

December 8 – birth of Camille Claudel. Her father was Louis-Prosper Claudel, Registrar of Fees and Stamp Duties at Fère-en-Tardenois (Aisne). Her mother was Louise Athanaïse Cerveaux, daughter of Athanaïse Cerveaux, doctor at Fère.

1865

January 25 – baptized by Nicolas Cerveaux, priest of the village of Villeneuve-sur-Fère and uncle of Louise Athanaïse Cerveaux.

1866

February 26 – birth of Louise Claudel.

1868

August 6 – birth of Paul Claudel.

1869

The Claudels reside at Bar-le-Duc (in the Meuse region). Camille Claudel attends the school of the Sisters of the Christian Doctrine.

1876-1879

Louis-Prosper Claudel is appointed Warden of Mortgages at Nogent-sur-Seine (in the Aube region). The Claudel children study with a tutor named Colin. Camille Claudel creates her first sculptures in clay of heroic figures, such as David and Goliath, Bismarck and Napoleon. Alfred Boucher, a talented sculptor from Nogent, notices the abilities of the young girl.

1879-1881

Her father is transferred to Wassy-sur-Blaise (in the Haute Marne region).

1881

Mme. Claudel and her children move to Paris. They settle at 135 bis, boulevard du Montparnasse. Claudel executes *Buste de Paul Claudel à treize ans* (plaster). Paul enrolls at the Lycee Louis-le-Grand. Claudel attends the Académie Colarossi and rents a studio 117 Rue Notre-Dame-des Champs with several English girls.

1882

Claudel is introduced to Paul Dubois, Director of l'Ecole Nationale des Beaux-Arts, by Alfred Boucher. She creates *La Vieille Hélène* in terra cotta.

1883

Her father is transferred to Rambouillet. Claudel creates: *Buste de Paul Claudel à seize ans* (plaster), *L'Ecume* (marble and onyx), *Buste de femme aux yeux clos* (plaster), *Buste de Paul Claudel* (missing) and *Portrait de Madame Louis-Prosper Claudel* (oil on canvas, missing). Rodin, who replaced Alfred Boucher as Claudel's instructor, accepts her as a student in his workshop at 182, rue de l'Universite.

1884

Buste de jeune femme aux yeux clos created in terra cotta.

1885

The Claudel family moves to 31-33, boulevard de Port-Royal. Camille Claudel vacations in the Vosges mountains with her family. There she draws several sketches and creates: *Buste de Louise Claudel* (terra cotta), *Mon frère* or *Le Jeune romain* (dyed plaster), *Giganti* (bronze) and *Torse de femme debout* (bronze).

1886

Claudel travels with her brother Paul to the Isle of Wight in the autumn. She has an exhibition in Nottingham with her workshop friend Jessie Lipscomb. She creates: *Portrait de Jessie* (terra cotta) and *L'Homme penché* (plaster).

1887

Her father is transferred to Compiègne. Claudel creates: *Portrait de Rodin* (oil, missing), *Portrait de Maria Paillette* (oil), *Portrait d'Eugenie Plé* (oil, missing), *Portrait de Louise de Massary* (pastel) and *Portrait de Victoire Brunet* (oil, missing). She travels to Touraine with Rodin.

1888

Louise Claudel marries Ferdinand de Massary, a magistrate. Rodin rents a workshop called La Folie Neubourg, an old ruin of an 18th-century house, to work there with Claudel (68, boulevard d'Italie). Claudel meets Claude Debussy and travels to the Isle of Wight with Jessie Lipscomb. Creations: *Sakountala* (plaster, awarded an honorable mention at the Salon des Artistes Français), *Torse de femme accroupie* (bronze), *Paul Claudel à vingt ans* (pastel) and *Buste d'Auguste Rodin* (bronze).

1889

Claudel creates: *Charles Lhermitte enfant* (bronze) and *Psaume* (bronze). Rodin becomes a founding member of the Société Nationale des Beaux-Arts.

1890

Claudel stays at the Château de l'Islette near Azay-le-Rideau.

1892

First model of *La Valse* (plaster). Claudel rents a workshop on boulevard d'Italie.

1893

Claudel travels to Touraine. Creates: *La Valse* (plaster, full size) and *Clotho* (plaster). Becomes a member of the Société Nationale des Beaux-Arts.

1894

Claudel stays in Guernsey. Creates: *Portrait du peintre* (bronze, missing), *Les Causeuses* (plaster), *La Petite châtelaine* (plaster) and *Le Dieu envolé*. Travels to Touraine.

1895

Commissioned by the state for the sculpture *L'Age mûr* (first version). Commission for *Clotho*, marble, to commemorate the banquet honoring Puvis de Chavannes.

1896

Meets Mathias Morhardt, Editor-in-Chief of the newspaper *Le Temps* and her first biographer. Ferdinand de Massary, her brother-in-law, dies. Creates: *La Petite châtelaine* (marble). A sandstone copy of *La Valse* is exhibited at the Salon de L'Art Nouveau held at Samuel Bing's hotel.

1897

An exposition of Claudel's work at Samuel Bing's home includes *L'Hamadryade* (marble and bronze, missing). Creates: *La Vague* (plaster) and *Clotho* (marble).

1898

Rents a workshop at 19, Quai Bourbon. Resigns from the Société Nationale des Beaux-Arts. Creates: *La Profonde pensée* (bronze and onyx), *Le Comte de Maigret en costume Henri II* (marble), *Persée et la Gorgone* (plaster, full size, missing), *L'Age mûr* (second version, plaster) and *Petite fille aux colombes* (oil on canvas).

1900

Shows three works at the Exposition Universelle. Meets Eugène Blot, who becomes her caster and friend. Creates: *Jeune femme au divan* (oil on canvas) and *Portrait d'une amie anglaise* (oil on canvas).

1902

Creates *L'Alsacienne* (silver-glazed terra cotta, three-quarter life size, missing) and *Buste de Madame de Maigret* (marble). Refuses to exhibit in Prague with Rodin.

1903

Creates *L'Age mûr* (bronze).

1905

Travels to the Pyrenees with her brother and friends. Paul Claudel writes "Camille Claudel statuaire," published in *L'Occident* and "Rodin ou L'homme de génie," which remained unpublished until volume eighteen of his complete writings appeared. Claudel creates: *L'Abandon* (bronze), *La Joueuse de flûte* (bronze), *Paul Claudel à trente-sept ans* (plaster), *Vertumne et Pomone* (marble), *Persée et la Gorgone* (bronze), *L'Aurore* (marble), *La Profonde pensée* (marble), and *Femme se chauffant devant une cheminée ou Rêve au coin du feu*. Claudel exhibits at Eugène Blot's art gallery.

1906

First symptoms of her mental illness. Creates *Niobide blessée* (bronze, commissioned by the state).

1908

Exhibits at Eugène Blot's art gallery.

1910

Creates *Buste de Paul Claudel à quarante-deux ans* (bronze).

1913

Her father, Louis-Prosper Claudel, dies on March 2 at Villeneuve-sur-Fère. Camille Claudel is interned at the psychiatric hospital of Ville-Evrard on March 10. In July a special issue of *Art Décoratif* magazine is dedicated to Camille Claudel by her brother.

1914

In August Claudel is transferred to a hospital in Enghien and then in September to one at Montdevergues, near Avignon.

1917

Auguste Rodin marries Rose Beuret on January 29. Beuret dies on February 14. Rodin dies on November 17.

1929

Her mother, Louise Athanaïse Claudel, dies on June 20.

1935

Louise de Massary, her sister, dies on May 3.

1943

Camille Claudel dies at Montdevergues on October 19.

Works of Art in Exhibition

1.

Buste d'homme [Bismarck]
Bust of a man [Bismarck]
1879-1880
(Attributed to Camille Claudel)
Clay, 11 7/8×7 7/8×11 7/8 in.
On loan from Ville de Wassy

2.

Buste de Paul Claudel à treize ans
Bust of Paul Claudel at thirteen
1881
Bronze on block of red marble,
15 3/4×14 1/8 in., 2×8 5/8 in.
Signed on back: C. Claudel
Musée Bertrand de Châteauroux
Provenance: Collection A. de Rothschild;
gift A. de Rothschild to the Musée Ber-
trand de Châteauroux in 1903.

3.

La Vieille Hélène
Helen in old age
1905
Bronze, 11×7 1/8×8 1/4 in.
Cast by Thiébaut Frères
Private collection
Note: Plaster (1882) exhibited at the Salon
des Artistes Français; terra cotta (1885)
exhibited at the Salon des Artistes Français
under the title *Buste de vieille femme*.

4.

Buste de femme ou *Buste de Madame
de Maigret*
Bust of a woman or Bust of Madame de
Maigret
ca. 1900
Plaster, 15 3/4×8 5/8×4 3/4 in.
Private collection

5.

Torse de femme accroupie
Torso of a woman squatting
1884-1885
Bronze, 13 3/4×8 1/4×7 1/2 in.
Private collection

6.

Mon frère ou *Le Jeune romain*
My brother or The young Roman
1884
Bronze, 17 3/8×17×9 1/2 in.
Signed at base of left shoulder: Camille
Claudel
Musée de Toulon
Provenance: Gift of A. de Rothschild to
the Musée d'Art et Archéologie de Toulon
in 1899.

7.

*Etude pour l'avarice et la luxure de
Rodin*
Study for Rodin's *Greed and Lust*
1885
Plaster, height: 7 7/8 in.
Private collection

8.

Buste de jeune femme aux yeux clos
Bust of a young woman with closed eyes
1987
Bronze, 14 5/8×13 3/4×7 5/8 in.
Private collection
Provenance: Exhibited for the first time,
this work was given by the artist's family to
Abbot Godet of Villeneuve-sur-Fère dur-
ing World War I.
Note: Terra cotta (1884)

9.

*Buste de jeune fille, Louise de Mas-
sary*
Bust of a young girl, Louise de Massary
1886
Bronze, 19 3/8×7 1/8 in.
Provenance: Gift of Baron Nathaniel de
Rothschild to the Musée Bargoin de
Clermont-Ferrand in 1887.
Note: Terra cotta (1885)

10.

Buste de Ferdinand de Massary
Bust of Ferdinand de Massary
1888
Plaster, 17×11×11 7/8 in.
Private collection
Note: Bronze (1889)

11.

Torse de femme debout
Torso of a woman standing
1888
Bronze, 19 3/8×6 3/8×13 3/4 in.
Cast by P. Converset
Signed: C. Claudel
Private collection
Provenance: Work recently rediscovered.
Note: Plaster (1884) missing

12.

Etude de tête d'enfant
Study of the head of a child
ca. 1895
Plaster, height: 7 7/8 in.
Private collection

13.

Sakountala

1987
Bronze, 74 7/8×43 3/8×23 5/8 in.
Signed on front at base of block: Camille Claudel
Private collection
Provenance: A gift in plaster was made by Camille Claudel to the Musée Bertrand de Châteauroux.
Note: The work received an honorable mention at the Salon des Artistes Français in 1888.

14.

Buste de Charles Lhermitte
Bust of Charles Lhermitte

1895
Bronze, 11 7/8×11 7/8×9 in.
Cast by Gruet
Signed on left shoulder: C. Claudel
Private collection

15.

Buste d'Auguste Rodin
Bust of Auguste Rodin

1892
Bronze, 15 3/4×9 7/8×11 in.
Signed on back: Camille Claudel
Alfred Baud, Geneva
Provenance: A copy belonging to Rodin was exhibited at the Société Nationale des Beaux-Arts in 1892. In addition, *Le Mercure de France* issued fifteen copies cast by Alexis Rudier.
Note: Plaster (1888-1892)

16.

L'Abandon
Abandonment

1888-1905
Bronze, 17×14 1/8×7 1/2 in.
Cast by Eugène Blot no. 2
Signed at back of base: C. Claudel
Private collection

17.

Buste de Léon Lhermitte
Bust of Léon Lhermitte

1893-1895
Bronze, 13 3/4×9 7/8×9 7/8 in.
Signed on right shoulder: Camille Claudel
Private collection

18.

Psaume ou *La Prière* ou *Buste de femme au capuchon*
Psalm or The prayer or Bust of a lady with a hood

1889
Bronze, 17 3/4×12 1/4 in., 2×15 in.
Cast by Gruet
Signed on block at left: Camille Claudel
Musée Boucher de Perthes, Abbeville
Provenance: Gift of A. de Rothschild to the Musée d'Abbeville et Ponthieu in 1893.

19.

Jeune fille à la gerbe
Young girl with a sheaf

1983
Bronze, 14 1/8×8 1/4×8 1/4 in.
Signed on base at left: Camille Claudel
Private collection

20.

Main
Hand

ca. 1885
Bronze, height: 2 in.
Signed on wrist: C. Claudel
Private collection

21.

La Valse
The waltz

1891-1905
Bronze, 18 1/8 in., 1 1/2×13×7 1/2 in., 2 3/4 in.
Cast by Eugène Blot no. 5
Signed on the left base: C. Claudel
Private collection

22.

La Petite châtelaine
The little mistress

1893-1894
Bronze, 13×11×8 5/8 in.
Signed on back: C. Claudel
Private collection

23.

La Petite châtelaine
The little mistress

1896
Marble, 17 3/8×9 7/8×13 3/4 in.
Private collection
Provenance: Formerly the Fountaine Collection

24.

La Petite châtelaine
The little mistress

1896
Marble, 17 3/8×13 3/8×11 7/8 in.
Signed on marble base: Camille Claudel
Private collection

25.

Tête de vieil aveugle chantant
Head of an old blindman singing

1894
Plaster, height: 7 7/8 in.
Private collection

26.

L'Age mûr
Maturity

1907
Bronze, 31 1/2×21 5/8×13 in.
Cast by Eugène Blot no. 3
Provenance: Reduced by Eugène Blot from a plaster original and exhibited in his gallery in 1907.

27.

L'Implorante
The implorer

1905
Bronze, 24 3/8×26×14 5/8 in.
Cast by Eugène Blot
Signed on block: C. Claudel
Private collection

28.

Le Dieu envolé
God flown away

Bronze, 28 3/8×22×15 in.
Cast by Valsuani
Signed on base: C. Claudel
Private collection
Note: Plaster (1894). This work is often confused with *L'Implorante*.

29.

L'Ecume
The foam
1897
Marble and onyx, 9 in., 2×15 3/4×6 in.
Signed on block: Camille Claudel
Private collection

30.

Femme à sa toilette
Woman at her dressing table
ca. 1895-1897
Plaster, 15 3/8×14 1/8×10 5/8 in.
Private collection

31.

La Vague
The wave
1897-1898
Bronze and onyx, 24 3/8×22×19 3/4 in.
Private collection

32.

Chien rongeant son os
Dog gnawing a bone
1898
Bronze, 6 3/8×8 5/8×4 in.
Cast by Alexis Rudier
Signed on front of plinth: Camille Claudel
Private collection
Note: Plaster (ca. 1894)

33.

La Profonde pensée ou *Femme agenouillée devant une cheminée*
Deep thought or Woman kneeling in front of a fireplace
1905
Bronze and onyx with lamp, 9 1/2×
8 5/8×10 5/8 in., 2 in.
Cast by Eugène Blot
Signed on block: C. Claudel
Provenance: Work recently rediscovered. Appeared in the 1905 exihibition organized by Eugène Blot.

34.

Persée et la Gorgone
Perseus and the Gorgon
1898-1902

Marble, 77 1/4×43 3/4×39 in.
Signed on block: Camille Claudel
Private collection
Provenance: Work commissioned from Camille Claudel by the Countess de Maigret. ·
Note: Exhibited in 1902

35.

Persée et la Gorgone
Perseus and the Gorgon
1898-1905
Bronze, 20×11 3/4×9 3/4 in.
Signed on base: Camille Claudel
Private collection

36.

L'Homme aux bras croisés
Man with crossed arms
ca. 1885
Terra cotta, 4×3 1/2 in., 2×3 1/8 in.
Private collection

37.

L'Aurore
The dawn
1905
Marble, 13 3/4×11 3/8×11 7/8 in.
Signed on back: C. Claudel
Private collection

38.

La Fortune
The fortune
1905
Bronze, 18 7/8×13 3/4×6 3/4 in., 2 in.
Cast by Eugène Blot no. 12
Signed on back of block: C. Claudel
Private collection
Provenance: Eugène Blot acquired the plaster in 1900, when he visited Claudel in her studio on the Quai Bourbon.

39.

La Joueuse de flûte
The flute player
1900-1905
Bronze, 13×7 7/8×12 1/4 in.
Cast by Eugène Blot no. 3
Signed on base: C. Claudel
Private collection

40.

Les Causeuses
The gossips
1893-1905
Bronze and marble, 13×7 7/8×12 1/4 in.
Cast by Eugène Blot (one-of-a-kind)
Private collection

41.

Buste de Paul Claudel à trente-sept ans
Bust of Paul Claudel at thirty-seven
1905
Plaster, height: 11 7/8 in.
Private collection

42.

Buste de Paul Claudel à quarante-deux ans
Bust of Paul Claudel at forty-two
1910
Bronze, 18 7/8×20 1/2×12 1/4 in.
Signed on base of shoulder: Camille Claudel
Private collection
Provenance: Six copies reproduced by painter Henry Lerolle.

43.

Etude de tête d'enfant
Study of the head of a child
ca. 1895
Plaster, height: 7 7/8 in.
Private collection

44.

Etude de tête d'enfant
Study of the head of a child
Before 1913
Bronze, 9 7/8×3 1/8×3 1/8 in.
Cast by Eugène Blot no. 1
Signed on back: C. Claudel
Private collection

45.

Etude de tête de jeune fille au chignon
Study of the head of a young girl with a chignon
Before 1913
Terra cotta, 11 7/8×4 3/8×4 3/4 in.
Private collection

46.

Tête de vieille femme
Head of an old woman

Before 1913
Plaster, height: 7 7/8 in.
Private collection

47.

Diane

Plaster, height: 7 7/8 in.
Private collection

48.

L'Homme penché
The man bending over

1886
Plaster, 16 1/2×6 3/4×9 7/8 in.
Private collection

49.

Portrait de Paul Claudel à vingt ans
Portrait of Paul Claudel at twenty

1888
Pastel, 17×13 3/4 in.
Private collection

50.

Portrait de Maria Paillette
Portrait of Maria Paillette

1887
Oil on canvas, 31 1/2×23 1/4 in.
Private collection

51.

Petite fille aux colombes
Little girl with doves

1898
Oil on canvas, 49 1/4×51 1/4 in.
Signed: C. Claudel
Private collection
Provenance: Work recently discovered.

52.

Portrait de Madame de Maigret
Portrait of Madame de Maigret

1903
Charcoal, chalk and pastel on paper,
20 7/8×26 in.

Signed and dated at bottom right: Souvenir de Senlis 1903, C. Claudel
Musée Municipal, Château-Gontier

53.

Jeune femme au divan
Young woman on the sofa

1900
Oil on canvas, 28 3/4×36 1/4 in.
Signed at top right: Camille Claudel
Private collection
Provenance: Work recently discovered.

54.

Femme de Gerardmer
Woman from Gerardmer

1885
Charcoal and chalk on paper, 18 7/8×
14 5/8 in.
Signed and dated at bottom right: Camille
Claudel
Gerardmer August 29, 1885
Musée Eugène Boudin, Honfleur
Provenance: Gift of A. de Rothschild to
the Musée Eugène Boudin in Honfleur.

55.

A Quiet Nap

1886
Original reproduction of a charcoal drawing, 15×10 1/4 in.
Musée Archéologique de Laon

56.

Le docteur Jeans
Doctor Jeans

1886
Original reproduction of a charcoal drawing, 14 5/8 ×10 1/4 in.
Musée Archéologique de Laon

57.

A Fisher Woman

1886
Original reproduction of a charcoal drawing, 14 5/8 ×10 1/4 in.
Musée Archéologique de Laon

58.

Old Granny

1886
Original reproduction of a charcoal drawing, 15 3/8×10 3/4 in.
Musée Archéologique de Laon

59.

Le Reveil ou *Douce remontrance*
The awakening or Sweet protest

1892?
Commissioned drawing
Facsimile of a pen and brown ink on
paper, 7×10 1/2 in.
Inscription with pen in lower right corner:
"Le reveil ou douce remonstrance par
Brunet."
On the reverse side: same scene reversed
Musée Rodin, Paris

60.

Le Système cellulaire
Prison conditions

1892?
Facsimile of a pen and ink wash on paper,
7 1/4×10 3/4 in.
Musée Rodin, Paris

61.

Le Système cellulaire
Prison conditions

1892?
Facsimile of a pen and ink wash, 7 1/4×
10 3/4 in.
Musée Rodin, Paris

62.

Le Collage
Cohabitation

1892?
Facsimile of a pen and brown ink on
paper, 8 1/4×10 3/8 in.
Inscription on front: "Ah! ben vrai! ce que
ca tient!"
On the reverse side: Letterhead from Palais
du Champ de Mars, S.N.B.A.
Musée Rodin, Paris

63.

Rodin sur le morceau
Rodin contemplating a fragment
1895-1896
Facsimile of a commissioned drawing,
7 7/8×10 1/8 in.
Musée Rodin, Paris

64.

La France
France
Auguste Rodin
1904
Bronze, 19 3/4×16 1/2×14 1/8 in.
Signed at base: A. Rodin
Private collection

Additional works on view in Washington, D.C.

65.

Portrait de Camille Claudel
Portrait of Camille Claudel
Auguste Rodin
1884
Bronze, 10 1/2×8×8 3/8 in.
Signed on left of base
Musée Rodin, Paris, Inv. S. 1005
Photo: Eric Emo

66.

Mademoiselle Camille Claudel
Auguste Rodin
1889
Bronze, height: 9 1/2 in.
Bridgestone Museum of Art,
Ishibashi Foundation, Tokyo

67.

Galatea
Auguste Rodin,
ca. 1890
Marble, 24×16×15 3/8 in.
Signed on inside left of base
Musée Rodin, Paris, Inv. S. 1110
Photo: Eric Emo

68.

Portrait d'une amie anglaise
Portrait of an English friend
1900
Oil on canvas, 25 1/4×21 1/4 in.
Signed and dated
Private collection
Provenance: Work recently discovered.

69.

Vertumne et Pomone
Vertumnus and Pomona
1905
Marble, 35 7/8×31 1/2×16 1/8 in.
Signed on back of base: C. Claudel
Musée Rodin, Paris, Inv. S. 1293
Provenance: Maigret Collection in 1905;
Philippe Berthelot Collection; Paul
Claudel Collection; gift of Paul Claudel to
Musée Rodin in 1952.
Photo: Bruno Jarret

70.

La Valse
The waltz
1891-1905
Bronze, 38 5/8×31 1/2×25 5/8 in.
Signed on base: C. Claudel
Private collection

71.

La Petite châtelaine
The little mistress
Marble, 13 5/8×11 1/8×8 7/8 in.
Signed on bottom of base
Musée Rodin, Paris, Inv. S. 1007
Photo: Bruno Jarret

72.

L'Aurore
The dawn
Auguste Rodin
1885
Marble, 22 1/8×23 5/8×21 in.
Musée Rodin, Paris, Inv. S. 1019
Photo: Eric Emo

Bibliography

Books:

Antoine, G. *Paul Claudel, biographie.* Paris: Robert Laffont, 1988.

Bénézit, E. *Dictionnaire des peintres, sculpteurs, dessinateurs et graveurs.* Paris: Grund, 1976.

Bénédite, L. *Histoire des Beaux-Arts, 1800-1900.* Paris.

——. *Les Sculpteurs français contemporains.* Paris: H. Laurens, 1901.

Benoist, L. *Histoire de la sculpture.* Paris: Presses Universitaires de France, 1965. *(Que Sais-je?)*

Blanche, J.E. *La Vie artistique sous la IIIème République.* Paris: Editions de France, 1931.

Blot, E. *Histoire d'une collection de tableaux modernes.* Paris: Editions d'art, 1934.

Cassar, J. *Dossier Camille Claudel.* Paris: Librairie Séguier, 1987.

Cassou, J. *Panorama des arts plastiques.* Paris: Gallimard, 1965.

Charmet, R. *Dictionnaire de l'art contemporain.* Paris, Larousse, 1965.

Chaigne, L. *Vie de Paul Claudel.* Tours: Mame, 1962.

Champigneule, B. *Rodin.* Paris: Somogy, 1967.

Champion, P. *Marcel Schwob et son temps.* Paris: Grasset, 1927.

Cladel, J. *Rodin, sa vie glorieuse et inconnue.* Paris: Grasset, 1936.

Claris, E. *De l'Impressionnisme en sculpture.* Paris: La Nouvelle Revue, 1902.

Claudel, P. *Journal* (1904-1932), 2 vols. Paris: Gallimard, 1968.

——. *Journal* (1933-1955). Paris: Gallimard, 1969.

——. *Correspondance avec Francis Jammes et Gabriel Frizeau (1897-1938).* Paris: Gallimard, 1952.

——. *Correspondance avec André Gide* (1899-1926). Paris: Gallimard, 1949.

——. "La Rose et le rosaire," in *Oeuvres Complètes,* XXI. Paris: Gallimard, 1964.

——. *Oeuvres en prose.* Paris: Gallimard, 1969. Bibliothèque de la Pléiade.

——. "Seigneur, apprenez-nous à prier." Dans *Oeuvres Complètes,* XXIII. Paris: Gallimard, 1964.

Daix, P. *Rodin,* Paris: Calmann-Levy, 1988.

Daudet, L. *Fantômes et vivants.* Paris: Nouvelle Librairie Nationale, 1914.

——. *Paris vécu.* Paris: Gallimard, 1969.

Descharnes, R., et J.F. Chabrun. *Auguste Rodin.* Lausanne: Edita, 1967, et Paris: La Bibliothèque des Arts, 1967.

Elsen, A. *Rodin's Gates of Hell.* Minneapolis: University of Minnesota Press, 1960.

Fontainas, A., et L. Vauxcelles. *Histoire générale de l'art français de la Révolution à nos jours.* Tome II. Paris: Librairie de France, 1925.

Frisch, V., and J. Shipley. *Auguste Rodin: A Biography.* New York: Frederick A. Stokes and Co., 1939.

Gischia, L., et N. Vedrès. *La Sculpture en France depuis Rodin.* Paris: Seuil, 1954.

Guillemin, H. *Le Converti Paul Claudel.* Paris: Gallimard, 1968.

Gsell, P. *Auguste Rodin: L'Art* Entretiens réunis par Paul Gsell. Paris: Grasset, 1911.

Goncourt, E., et J. de Goncourt. *Journal: Mémoires de la vie littéraire et artistique.* 4 volumes. Paris: Fasquelle et Flammarion, 1959.

Grunfeld, F.V. *Rodin: A Biography.* New York: Henry Holt and Company, Inc., 1987.

Hess, T.B., and E.C. Baker. "Art and Sexual Politics." *Art News* series, New York: Macmillan Press, 1973.

Jianou, I. *Rodin.* Paris: Arted, 1980.

Kjellberg, P. *Les Bronzes de XIXème* siècle. Dictionnaire des sculpteurs. Les Editions de l'amateur, 1987.

Lami, S. *Dictionnaire des sculpteurs de l'école française du XIXème siècle.* Paris: Librairie ancienne Honoré Champion, 1921.

Lampert, C. *Rodin: Sculpture and Drawings.* London: Arts Council of Great Britain, 1986.

Letourneur, R. *La Sculpture française contemporaine.* Monaco: Les Documents d'art, 1944.

Lesort, P.A. *Claudel: Ecrivains de toujours.* Paris: Seuil, 1985.

Letheve, J. *La Vie quotidienne des artistes français de XIXème siècle.* Paris: Hachette, 1968.

Lockspeiser, E. *Claude Debussy.* Paris: Fayard, 1980.

Maillard, L. *Auguste Rodin: Statuaire.* Paris: H. Floury, 1899.

Mirbeau, O. *Des artistes.* 10/18 (1986). Série "Fins de siècle". UGE.

Mondor, H. *Claudel plus intime.* Paris: Gallimard, 1960.

Paris, R.M. *Camille Claudel.* Paris: Gallimard, 1984.

——. *Camille Claudel.* English translation. New York: Seaver Books, Henry Holt and Company, Inc., 1988.

——. *Principes d'analyse scientifique.* La Sculpture, Paris: Imprimerie Natl., 1984.

Read, H. *A Concise History of Modern Sculpture*. London: Thames and Hudson, Inc., 1964.

Renard, J. *Journal*. Paris: Gallimard, 1967.

Rilke, R.M. *Rodin and Other Prose Pieces*. London: Quartet Books, 1986.

Rivière, A. *L'Interdite*. Paris: Tierce, 1983.

Rudel, J. *Technique de la sculpture*. Paris: Presses Universitaires de France, 1980. *(Que Sais-je?)*

Tancock, J.L. *The Sculpture of Auguste Rodin*. Philadelphia: Philadelphia Museum of Art, 1976.

Selz, J. *Découverte de la sculpture moderne*. Lausanne: Les Fausonnières et La Guilde, 1963.

Société Paul Claudel. *Bulletins de la Société Paul Claudel*, Nos. 32-37-45-94. (Société Paul Claudel, 13, rue du Pont Louis-Phillipe, Paris 75004).

Thieme, U., et F. Becker. *Allgemeines Lexikon der Bildenden Kunstler von der Antike bis Zur Gegenwart*. Volume 7. Leipzig: W. Engelmann, 1907-1947.

Varillon, E. *Claudel*. Paris: Desclée de Brouwer, 1967. (Les écrivains devant Dieu)

Vollard, A. *Souvenirs d'un marchand de tableaux*. Paris: Albin Michel, 1984.

Weiss, D. *Naked Came I*. London: Hodder Paperback, 1971.

Articles:

Asselin, H. "Camille Claudel et les sirènes de la sculpture." *La Revue française* (avril 1966): 8.

——. "La Vie douloureuse de Camille Claudel, sculpteur." Texte dactylographié de deux émissions pour la Radio Television française, 1956. Fonds Claudel, Bibliothèque nationale.

Braisne, H. de. "Camille Claudel." *La Revue idéaliste*, no. 19 (19 octobre 1897).

Claudel, P. "Camille Claudel statuaire." *L'Occident* (août 1905). Reprinted in *L'Art décoratif* (juillet-décembre 1913), and *L'œil Ecoute, œuvres en prose*, Bibliothèque de la Pléiade.

Espiau de La Maestre, A. "L'Annonce faite à Marie." *Les lettres romanes* (1962) no.1: 3-26; no.2: 149-171 et no.3: 241-265, université catholique de Louvain.

Geffroy, G. *Revue de Paris*. (3ème trimestre, 1895): 428-448.

——. *La Vie artistique* (1893): 337; (1894): 380; (1895): 147-224; (1900): 349-432; (1901): 291, Paris.

——. "Çacountala." *Le Journal* (15 décembre 1895).

Gelber, L. "Camille Claudel's Art and Influences." *Claudel Studies*, vol. 1, no. 1 (1972): 36-43, Dallas.

Mirbeau, O. "Ça et là." *Le Journal, quotidien littéraire, artistique et politique*, (12 mai 1895).

Morhardt, M. "Mlle Camille Claudel." *Mercure de France*, (mars 1898).

——. "Sur un marbre disparu de Camille Claudel." *Le Temps* (14 septembre 1935), Paris.

Pingeot, A. "Le Chef-d'oeuvre de Camille Claudel: L'Age Mur." *La Revue du Louvre et des Musées de France* (octobre 1982): 292-295.

Vauxcelles, L. "A propos de Camille Claudel: Quelques oeuvres d'une grande artiste inconnue du public." *Gil Blas* (10 juillet 1913), Paris.

Wernick, R. "Camille Claudel's tempestuous Life of art and passion." *Smithsonian Magazine*, September, 1985.

Catalogues:

1905: *Exposition d'oeuvres de Camille Claudel et de Bernard Hoetger du 4 décembre au 16 décembre*. Paris: Galerie Eugène Blot.

1907: *Exposition de sculptures nouvelles par Camille Claudel et de peintures par Manguin, Marquet, Puy, du 24 octobre au 10 novembre*. Paris: Galerie Eugène Blot.

1908: *Exposition de Mesdames Camille Claudel, Gaston Devore, Jeanne Eliot, Alcide Lebeau, Hassenberg, Ann Osterlind du 1er au 24 décembre*. Paris: Galerie Eugène Blot.

1938: *Catalogue du Musée Rodin* (4ème edition). George Grappe. Paris: Musée Rodin.

1951: *Catalogue de l'exposition Camille Claudel*. Marcel Aubert and Cécile Goldscheider. Paris: Musée Rodin.

1957: *Rodin: Ses collaborateurs et ses amis*. Paris: Musée Rodin.

1965: *Catalogue de l'exposition Paul Claudel*. Paris: Bibliothèque littéraire Jacques Doucet.

1968: *Catalogue de l'exposition pour le centenaire de la naissance de Paul Claudel*. Paris: Bibliothèque nationale.

1972: *Catalogue de l'exposition Ernest Nivet*. Gisèle Chauvin. Châteauroux: Musée Bertrand.

1981: *Rodin Rediscovered* by Albert E. Elsen. Washington, D.C.: The National Gallery of Art.

1982: *De Carpeaux à Matisse: La sculpture française de 1850-1914 dans les musées et les collections publiques du nord de la France*. Edition de l'association des conservateurs de la Région Nord Pas-de-Calais.

1984: *Catalogue de l'exposition Camille Claudel*. Paris: Musée Rodin.

1984: *Debussy e il Simbolismo*. F. Lli Palombi Editori Cataloghi. Roma: Villa Medicis.

1985: *Anciens et nouveaux*. Choix d'oeuvres acquises par l'Etat ou avec sa participation de 1981 à 1985. Paris: Editions de la Réunion des Musées Nationaux.

1985: *Camille Claudel-Auguste Rodin: Dialogues d'artistes-resonances*. Bern: Kunstmuseum; Fribourg, Switz.: Office du Livre.

1986: *La Sculpture française au XIXème siècle*. Paris: Galeries Nationales du Grand Palais. Editions de la Réunion des Musées Nationaux.

1986: *La Femme et ses artistes*. Jean Monneret. Paris: Société des Artistes Indépendants.

1986: *Rodin: Sculpture and Drawings* by C. Lampert. London: Arts Council of Great Britain.

1986: *Grands maîtres de la sculpture: Mémoire d'une collection*. Salons de la Malmaison. Office Municipal de l'Action Culturelle et de la Communication de la Ville de Cannes.

1987: *Camille Claudel: Sculptures et photographies* 3-28 février. Institut Français d'Athènes.

1987: *Exposition Camille Claudel*. Japanese and French *catalogue for an exhibition organized by Asahi Shimbun which traveled in Japan from August 1987 through March 1988*.

1987: *National Museum of Women in the Arts*. New York: Harry N. Abrams, Inc.

Archives:

Archives nationales, Paris.

Archives du Musée Rodin, Paris.

Fonds Camille Claudel. Bibliothèque nationale, Paris.

Fonds Paul Claudel. Bibliothèque nationale, Paris.

Société des Manuscrits des Auteurs Français. Bibliothèque nationale, Paris.

Archives, Reine-Marie Paris.

Bulletins Société Paul Claudel no's. 32, 37, 45, 94

(Société Paul Claudel, 13 Rue du Pont Louis Philippe, Paris).